Introducing Relief Printing

Introducing Relief Printing

John O'Connor

B.T.Batsford Limited London
Watson-Guptill Publications New York

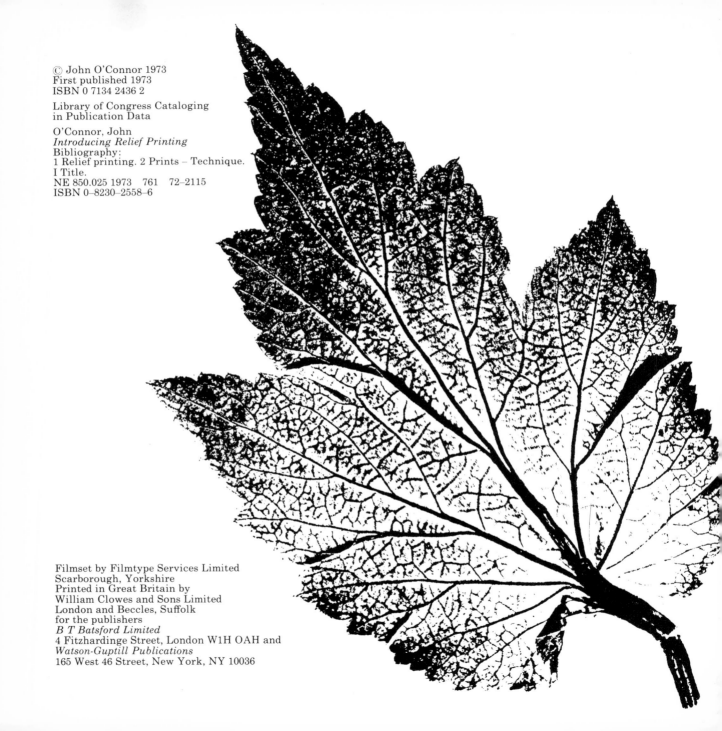

© John O'Connor 1973
First published 1973
ISBN 0 7134 2436 2

Library of Congress Cataloging
in Publication Data

O'Connor, John
Introducing Relief Printing
Bibliography:
1 Relief printing. 2 Prints – Technique.
I Title.
NE 850.025 1973 761 72–2115
ISBN 0–8230–2558–6

Filmset by Filmtype Services Limited
Scarborough, Yorkshire
Printed in Great Britain by
William Clowes and Sons Limited
London and Beccles, Suffolk
for the publishers
B T Batsford Limited
4 Fitzhardinge Street, London W1H OAH and
Watson-Guptill Publications
165 West 46 Street, New York, NY 10036

Contents

Acknowledgment

I would like to thank the following diploma students at St Martin's College of Art for the use of their work which is included in this book:

Anna Binns page 75
Sara Cole pages 74 and 128
Susan Curtis half-title and pages 10, 16, 17, 76, 77, 126 and 127
Barbara Dawson page 118
Margaret Dodsworth pages 50, 51, 52 and 53
Avraham Eilat pages 63, 64, 65, 124
Christopher Hoare pages 44 and 45
Valerie Ingram page 68
Susan Knobler page 20
Valerie Large pages 78, 79, 80, 81, 82, 83, 84, 85, 110, 119 and 120
Abla Mallat pages 86 and 87
Michael O'Connor pages 13, 14, 15, 69, 107 and 108
Glynis Owens page 66
James Parfit title-page, verso and pages 29, 30, 31, 72 and 73
Alan Weatherby 57, 60, 61 and 111

I would also like to thank Peter Green for his kind permission to include the prints on pages 22 and 23.

Shelley 1973 J. O'C

Introduction

Relief printing is a general term covering any form of printmaking in which an image is obtained from a surface coated with ink or pigment, covered with a piece of paper or suitable material under pressure or friction, so that, when removed, it bears an impression of the inked surface. This surface may be a linocut, woodcut, wood engraving or even a flower, leaf, feather, or any everyday object to be found in the home, workshop or school.

Of all forms of printing from primitive times to the present day, relief printing is the most direct. A print may be made either by placing the paper over the inked surface, or placing the inked surface over the paper laid flat, and making an impression by pressing or burnishing.

Rubbings from church brasses or gravestones and tomb inscriptions cut in slate or stone are all recognisable instances of relief printing. As the heel ball wax is rubbed on to the paper over the brass, the print appears as a result of this direct rubbing, although the wax does not come in contact with the brass surface. If ink or some other pigment were rolled thinly on to the metal and the paper laid over it before rubbing, then the print would appear when the paper was lifted from the surface.

Branding sheep or cattle, and printing from the sliced end of a potato or from a signet ring, are all forms of relief printing. The stamped name of a producer on the end of a

wooden packing crate will give just as good a print as a clean woodcut, wood engravings or linocut. There is scarcely a surface in day-to-day usage from which it is not possible to print by one method or another.

The process required to print from a soft woven mat of natural reed, for example, is the same as that used to print from a cog wheel, a dismantled clock, blades of straw or pieces of string; the difference is only in the quality of the padding for pressure, the use of soft or hard papers, the loose or stiff nature of the ink to be used, and whether the print is to be made in a press or by burnishing.

Notes on these processes are set alongside examples of prints which are here reproduced in the actual size in which they were made. A number of these prints, made by professional artists and by students, were originally printed in full colour, in several colours, or in tones or tints without restriction. For the purpose of easy reproduction in this book, the prints have been remade in black and white and tones of black in order to produce them in black and a second colour. The method of working is explained in each case, but the original colour in some instances is of a much wider range than is shown here. This fact (a reasonable commercial condition within the printing industry) is interesting as an example of the way in which an image, originally made for the process of relief printing, may be reorganised for presentation by another process. A woodcut or engraving, for example, may be printed excellently by a photographic process once a good original has been obtained. What will be lacking, of course, is any disturbance, impression or embossing which would show in a contact print.

After a single-colour uncomplicated print has been made, there are a large number of variations possible on the original theme. In some respects this resembles the variation on a musical theme, and in much the same way the original form will tend to be lost in the ensuing process. This fact, far from being a misfortune, is one of the unique properties of the making of relief images.

◀ Pencil rubbing

9

The limit of the size of the print is conditioned by the area of the paper or fabric to be printed and the accommodation available. A hand-burnished or rubbed print may be the area of the table, paper or floor space used; a press-made print will be limited by the length and width of the tympan (the top panel which covers the block before printing) and the bed or base plate of the press. As a rough guide, the best printing area of a nineteenth century or modern hand press is within 25 mm to 50 mm (1 in. to 2 in.) of the outside measurement of the platen (the metal plate which presses the paper against the surface to be printed in order to give the impression). Clearly the hand burnishing method is the less limiting of the two processes.

One obvious advantage of relief printing as an art form over other processes is that copies may be made and repeated of a motif or image. However, the making of a number of prints, ie an edition, is not the only end product of graphic print. A single, well made print, with interesting developments in its production will prove to be a most satisfactory enterprise to its maker. In fact the very blocks from which the images are made should be retained and will sometimes take their place as cherished surface decoration on wall or floor.

Lino print

Tools and materials

All print work requires similar basic materials and methods of impression, whatever modifications may be applied. Here is a list of materials which may be required during the several processes of relief printing.

Work area A reasonable working space should be at least 1·2 m to 1·8 m (4 ft to 6 ft) in length. If possible, arrange the table so that the light can come from the opposite side to which you are working. This will make it easier to check the thickness of ink, and to notice any particles of dust on the surface before printing.

Rolling-up surface A picture frame with well secured glass will do very well for this purpose. If glass is not available or is considered unsafe, tin sheeting, eg old litho plates, or formica make good alternatives. Failing these, paper can be used but it should be pinned to card so that it will not move.

Inks and pigments, solvents and cleaning materials
See page 55.

Rollers There should be at least two, one for rolling up ink, and one for taking an impression, ie rolling over the back of the material to be printed. The ink roller should

Woodcut in soft wood

be soft, the printing one harder. The diameter should be at least 50 mm (2 in.), and preferably 100 mm (4 in.). Most suppliers provide replacements for rollers which are outlasted by their handles. The rollers are made either of gelatine or composition, and it is useful to have one of each. Keep the rollers used for glycerine and oil-based inks quite separate. When working, do not allow the rollers to stand on the inking surface; they should either be hung from a screw by the handle, or stood on the rests which the larger rollers have on their frames.

Hand burnishers The best are: a simple bone folder as used by bookbinders, slightly tapered at the ends, a wooden or plastic kitchen spoon, a smoth-backed comb, or a shaped wooden tool used for modelling, obtained from artists' suppliers.

Printing paper or other printing material See page 54. For storing, keep the tins and tubes of ink, with the rollers and burnishers on the rolling up surface, at one side of the working table, and the paper or printing material at the other, leaving a good size printing area at the centre. Try to leave plenty of room for moving round the sides of the table. Keep a piece of hard card and a pad of newspaper in the central working area. The newspaper will afford a soft, resilient pack for printing uneven surfaces such as buttons, scissors, stems or reeds. The card is for laying over the printing paper when roller printing.

Cleaning rags These should be of good absorbent material. They are best kept in two boxes under the working table, one for clean rags and one for dirty ones. They must be kept separate. A print can easily be spoiled by using a dirty rag on a clean surface.

Press This is a desirable though not entirely necessary piece of printing equipment. The best would be an *Albion* or *Columbia* hand press with a bed of approximately

405 mm to 505 mm (16 in. to 20 in.) and would prove a good investment.

Rack for drying prints See page 56.

Wood, lino and other suitable materials for printing
For engraving, boxwood is undoubtedly the best, but for most printing processes, pear, apple, sycamore, hornbeam or maple woods may all be used to good effect.

For woodcutting, almost any hard or semi-hard wood will do, so long as it is dry and of not too coarse a grain.

For linocutting buy lino, if possible, from a furnishing store or educational suppliers. Use only untreated plain lino without pigment surface; it is generally brown or dark green in colour.

For other print materials see relevant chapters.

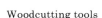

Woodcutting tools

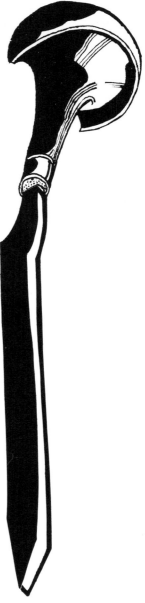

Burin Spitsticker Tint tool Square ended scorper

Cutters for wood and lino: wood engraving tools

Spitstickers These are general drawing tools, similar to the burin, which was the original engraving tool; they are narrow, leaf-shaped and of several different thicknesses.

Scorpers These are square or round edged cutters with narrow blades and chamfered (bevelled) edges for cutting. The section determines the round or square end.

Tint tools These are similar to spitstickers, but without the leaf section and with a thin triangular blade, the lower edge of which is slightly flattened.

Multiple cutters These are like square scorpers but with three, four or more grooves in the lower edge, so that a number of lines can be cut in one operation.

Wood and linocutting tools Simple V and U shaped cutters, with handles like those of the wood engraving tools. Carpenters' gouges and woodcarvers' tools with palm grip handles are excellent. A large range of sizes is available.

Honing stone This is for sharpening the cutters.

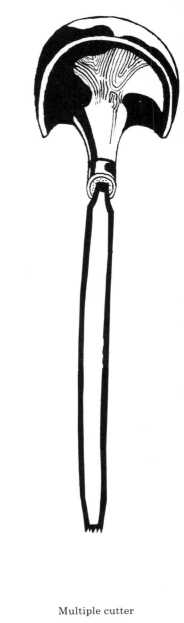

Round ended scorper

Multiple cutter

15

Methods of impression in printing

For relief printing, the impression can be taken either by a press or the hand burnishing method, although in certain instances one method will obviously be more suitable than the other.

Printing with a press If a press is available, this should be packed to the correct height for impression with card or blockboard (chipboard), according to the surface from which the print is to be taken; obviously, a thin card will require more packing than a wood engraving block.

Generally, the surface should be flat, but a slight warping or bow in the chosen pieces of wood, for example, will most probably flatten under the spring pressure of the press. Allow for the strength of this pressure, as it can easily crush and damage a surface if it is not protected at the sides by material equal in height to the printing surface in order to take the load at the edges. Occasionally, of course, crushing of the material may be done intentionally, but in this case, care must be taken to protect the press packing from an embossed impression of the print material. The effect may be interesting, but it will prevent use of the same packing on flat print work later.

The image, embossed from pressure, can be used with a blind effect (i.e. not inked), or made visible by a thin

layer of ink rolled over its surface. The embossed areas or lines will remain white on white paper and coloured on coloured paper, while the flat surface takes the ink colour from the roller. This is, in fact, a complete form of relief printing in itself, but it may not be possible to take any prints from the embossed piece unless the material is hardened or dries harder than when first used.

Printing by hand If no press is available, prints can be made by one of three methods.

1 By burnishing with a spoon, comb, bone folder or modelling tool. Burnishing prints is not a difficult process. To achieve an even-toned print, it is important that the burnisher is moved across the paper surface with a deliberate and rhythmic action, so that no areas are left untouched. If an uneven tone is required, selected areas of the block should be left unburnished.

2 By rolling a hard roller over the back of the printing surface. Roller printing has something of the effect of burnishing, but the roller has an all-over surface and even pressure, as opposed to the smaller surface of the burnishing tool. The advantage of roller printing is that an instant print is made, often by one roller action only, with good pressure from the shoulder. After a little experience, it is quite possible to feel irregularities in the surface through the roller in the hand, and pressure can be regulated accordingly. As with burnished prints, it is wise to fasten the paper at one end before rolling and to roll away from the fastened end.

3 By pressure from a heavy, hard, flat board over the surface. The upper and lower boards can be put on the floor and stood on for a moment or two. This method may sound primitive, but it was used a good deal in experimental work during the early twentieth century, and by some of the earliest woodcut printers in Germany and the Low Countries in the sixteenth and seventeenth centuries. Contemporary printmakers or artists who wish to incorporate a printed image in their work often use this simple method.

If the wood or printing surface is warped or uneven, it will often be necessary to print by hand, and in this case a fairly soft gelatine roller should be used, as it will adjust itself to irregularities of the surface under hand pressure.

When printing by any method, squeeze a little ink from the tube and replace the cap immediately, or from a tin of ink, with a palette knife, take a blob of ink the size of a thumb nail from one small area in the tin, and replace the tin lid immediately, to avoid drying. Take care to fold back the skin which protects the ink before using it.

Flatten out the ink on the inking slab with the palette knife, and roll it out gently in several directions, lifting the roller occasionally to even the surface, and also to prevent the edges of the roller making linear marks on the print.

All ink should be smooth and flat. If, however, a textured or heavily inked effect is required, this may be achieved by adding ink, or a roughening material such as fine sand, sawdust or iron filings, or by putting a fabric or interrupting surface between the ink and the printing paper. Before or after printing, roughening materials of any description – sugar, sequins, mini-beads, seeds, or any material which will fall in powder form, or lustre powders, bronze, green, blue, etc to give a surface quality – may be sifted over a print. Do not use this process, however, for printing wood or linocuts, because the line will fill up and a bad print will result.

New wood will absorb ink quickly; and it is a good plan to leave a trace of ink on the wood after the first proofing to give a bite to the ink applied later. This should not be sufficient to fill any delicate grain which may be desired in the proof. Such grain is interesting if printed from the same block at different angles during successive stages in a proof.

If a very clear print is required, a clean ink surface is essential, as even a speck of wool from a jersey, or particles of dust will make small spots or circles in what should be smooth areas, thus showing the difference between poor and efficient printing.

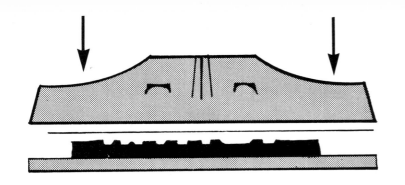

Printing with a press

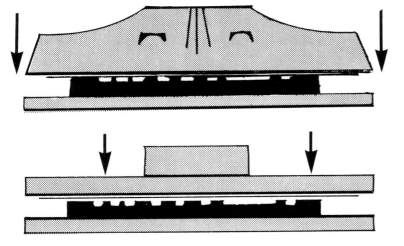

Printing with a press

Printing with boards and pressure

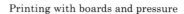

Printing with a roller

Burnishing a print by hand and spoon

19

The technique for printing on linen, silk, synthetic fibre fabrics, cotton, canvas or hessian (burlap), is exactly the same as for printing on paper. There will be a difference in the padding chosen, both for press use as well as for board press printing. It might be difficult to print by burnishing over soft fabrics unless the material is attached to the base board by thin paste or by a trapping device which would hold the cloth firmly at the edges.

Cleaning To clean a printing surface, lay a sheet of paper over the ink, and roll with a soft roller. Change the paper once or twice, then wipe the surface clean with a rag lightly charged with paraffin or white spirit cleanser, allowing it to remain there for a minute or two to break up the structure of the ink, and then wipe clean.

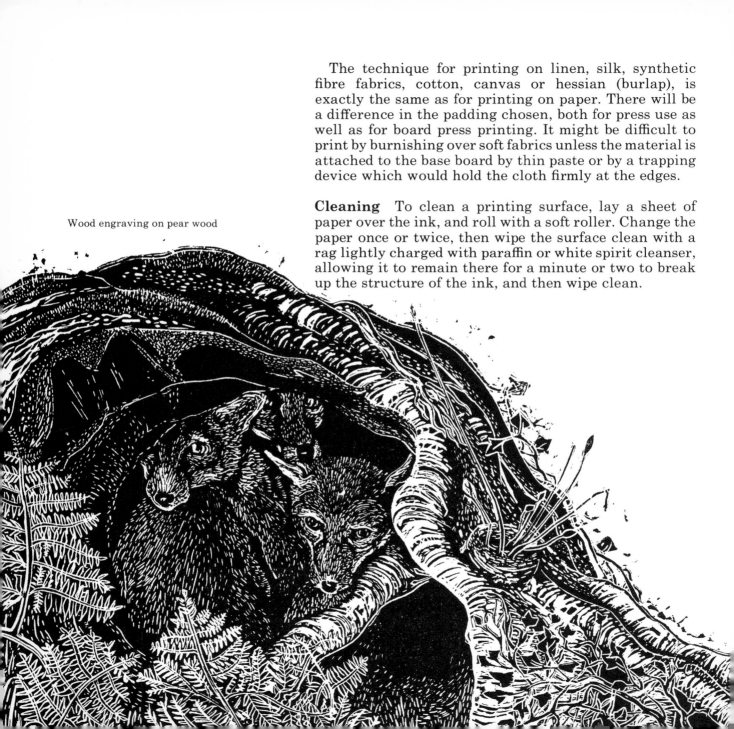

Wood engraving on pear wood

Prints from natural objects

Natural material for printing is easy to find, but the printing of it is limited by the thickness and strength of the chosen items. Leaves, freshly picked or dried, grasses, flower heads with shallow centres, feathers, weathered wood, wood shavings, corroded or etched metal plates, are all good print materials.

First, roll out the ink or pigment until it is thinly and evenly distributed on the surface of the roller. Hold the end of the material (say a feather) on to the paper, and roll lightly but firmly over the surface. Turn the feather over on to a piece of clean paper, lay a piece of lightweight paper over it, and apply a hard, clean roller over the whole area. Remove the top paper and the feather, slowly and carefully, and a print of the more prominent lines of the feather will remain. A feather is a good illustration of the way in which the finer lines will print as they are clean and distinct. There will, however, be a small white gap along the sides of the feather spine, as its thickness keeps the paper away from the ink. This is a welcome quality in relief printing and such gaps can be filled with colour in a later printing or with an overall tint from another block or printing surface.

If the first impression is not satisfactory, repeat the process with another feather; a fresh sheet of top paper and rolling surface paper will be needed, as there may be offset from the first print.

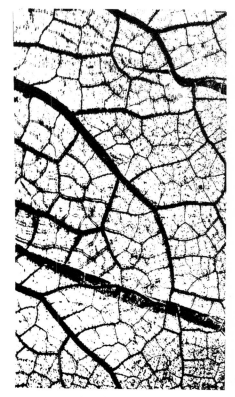

Direct print from leaf

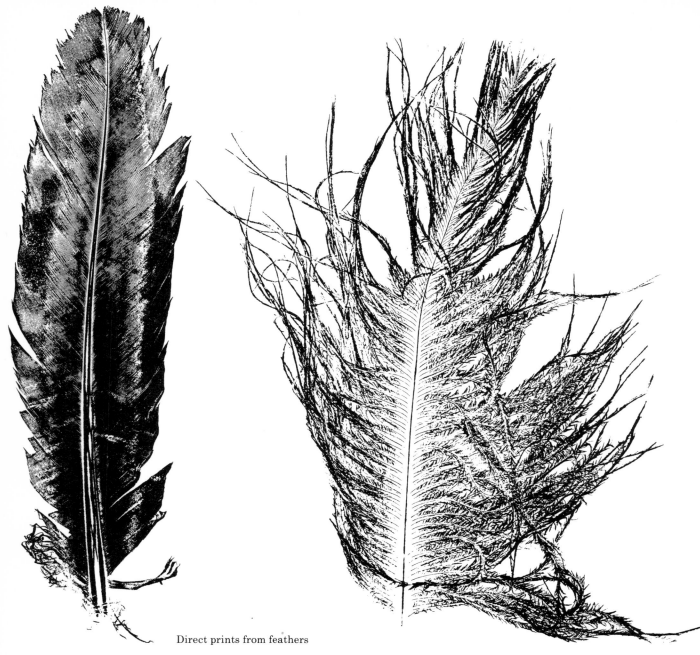

Direct prints from feathers

Once the feather or other chosen material has been printed, the paper on which it lay during rolling will bear an image of it, and this may be reprinted in any position under pressure on to the paper on which the first print has been made. Each reverse image made in this way will bear a diminishing volume of ink, being offset from the first print.

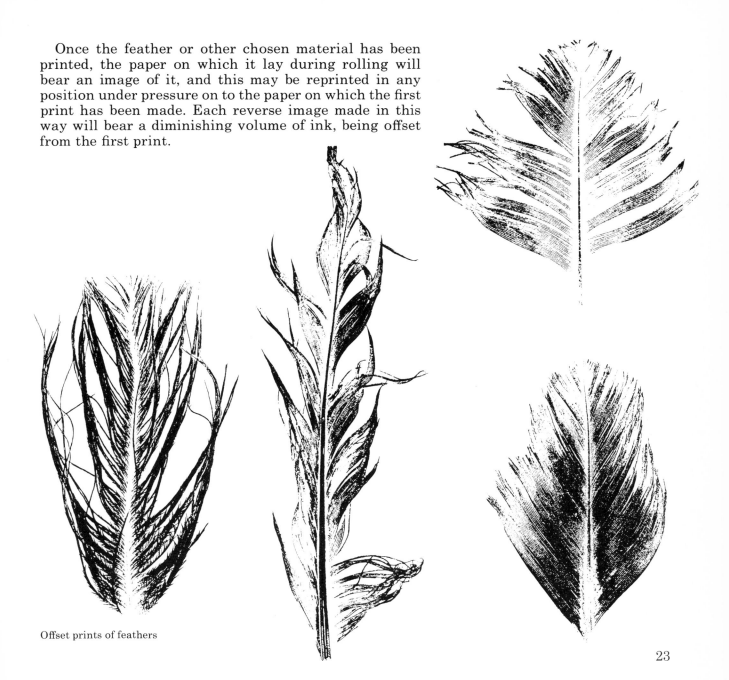

Offset prints of feathers

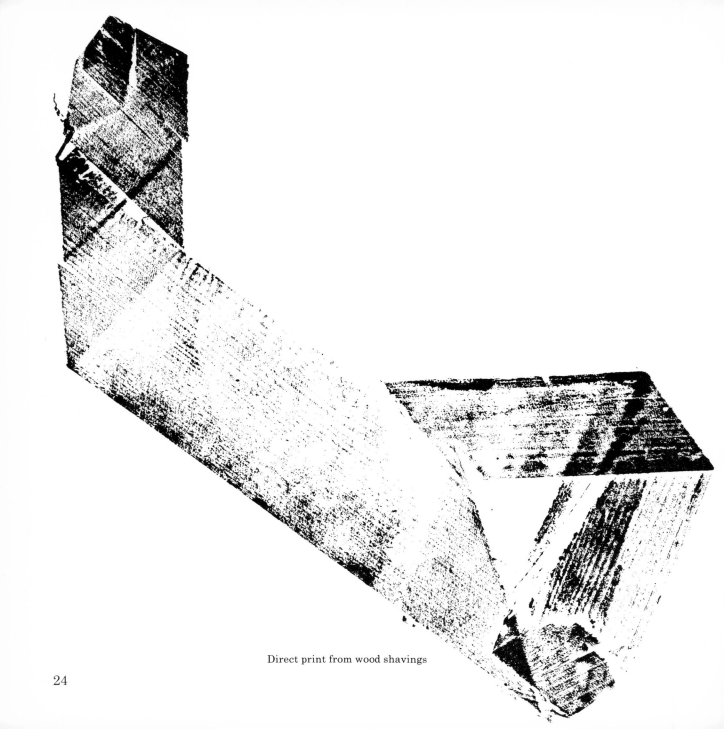

Direct print from wood shavings

Another method of printing this type of material is to roll up the ink very smoothly on the slab, place the object on it, cover with a protective paper and roll the surface firmly with a medium soft roller. Carefully lift the object from the slab, leaving a small end uninked to give a finger grip in a clean place, and put it down on the printing paper, which may have already received a previous print. A similar process applies to subsequent prints in black or colour, to be made on the same paper. Allow sufficient time for the ink to dry into the surface of the paper before taking additional colour images if these are to overlap – if the paper is hard and unsized, this may mean an hour or two; if soft and unsized, or with not much ink, drying will take about five or ten minutes. It is, in fact, conditioned by the temperature of the workshop and the drying speed of the ink. However, a thin layer of ink may be removed by rolling over a piece of clean, soft paper placed carefully over the new print. This will allow a second printing almost immediately.

Direct print from planed wood

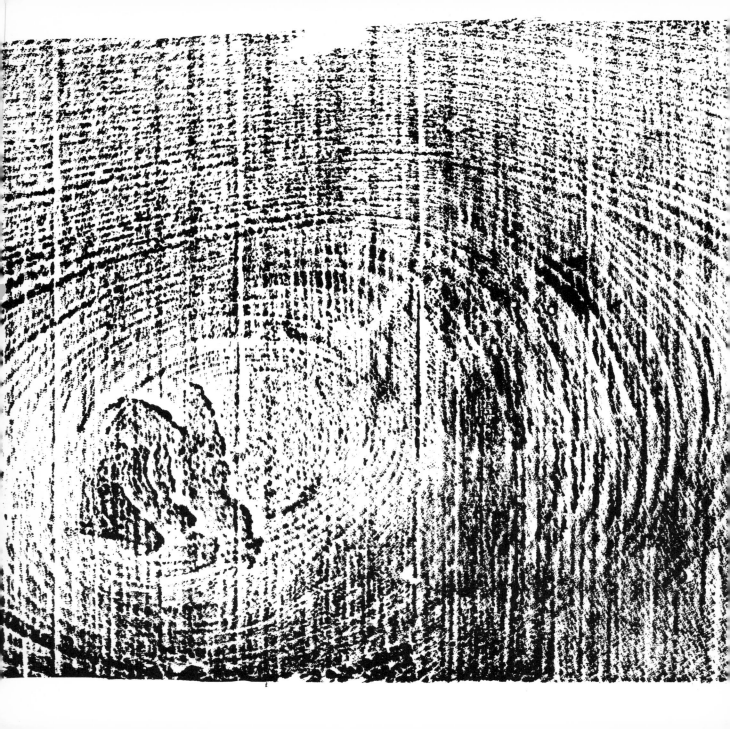

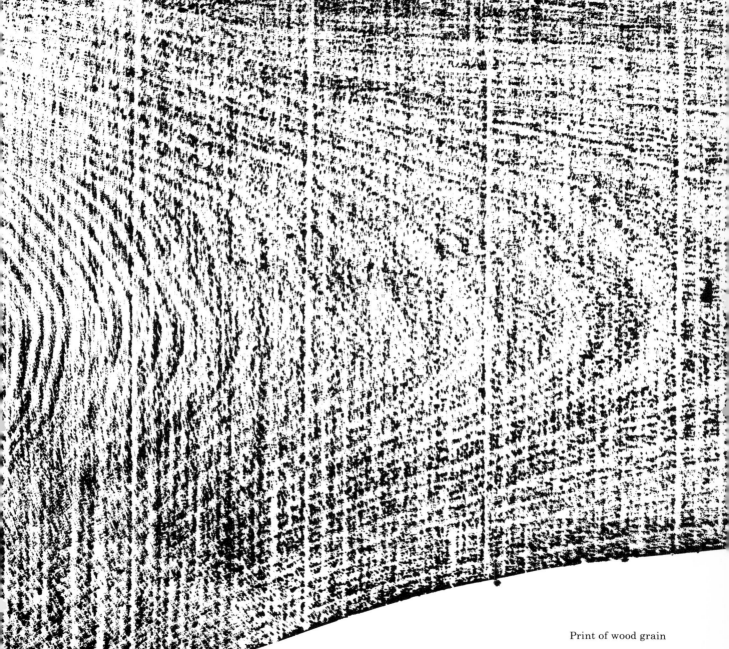

Print of wood grain

27

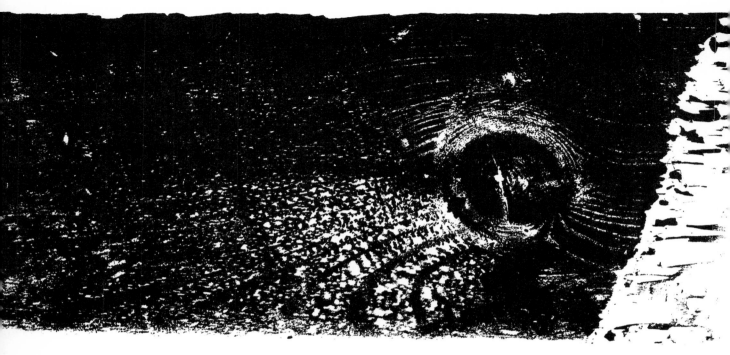

Direct print from a plank

When these processes are used with a press, care must be taken to ensure that there is a reasonably thick and slightly springy packing between the bed of the press and the platen, and several objects can be printed at one pulling of the press more easily than by the hand process.

A third method, often the most successful, is to print with foot pressure between two boards on the floor.

Sometimes the back image, or reverse shape of an object is more rewarding to the printer than the clear cut direct print. These materials can be associated in many different ways, and multiple images produced, claiming origin from natural forms which, through several processes, may have become unrecognisable. This is often an advantage in creating new designs.

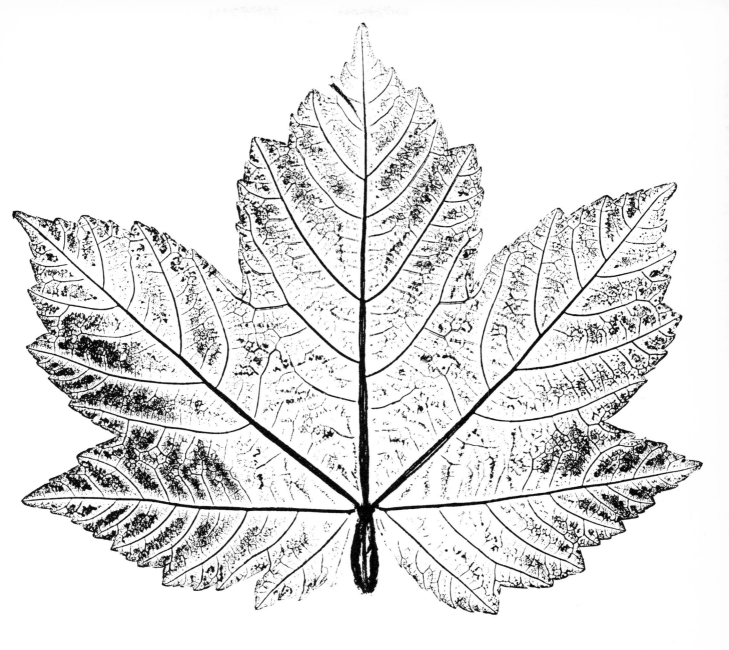

Direct print from a leaf

(overleaf) Offset print of grass

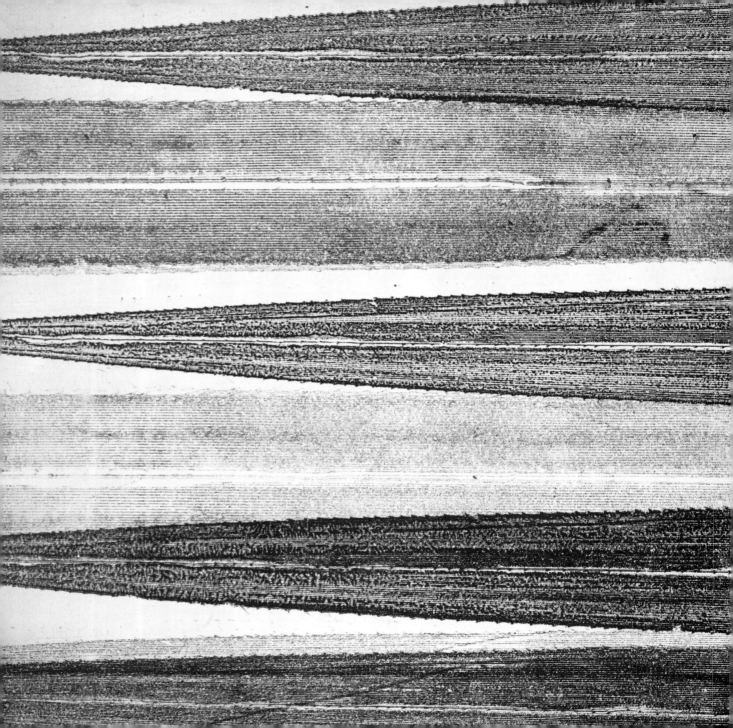

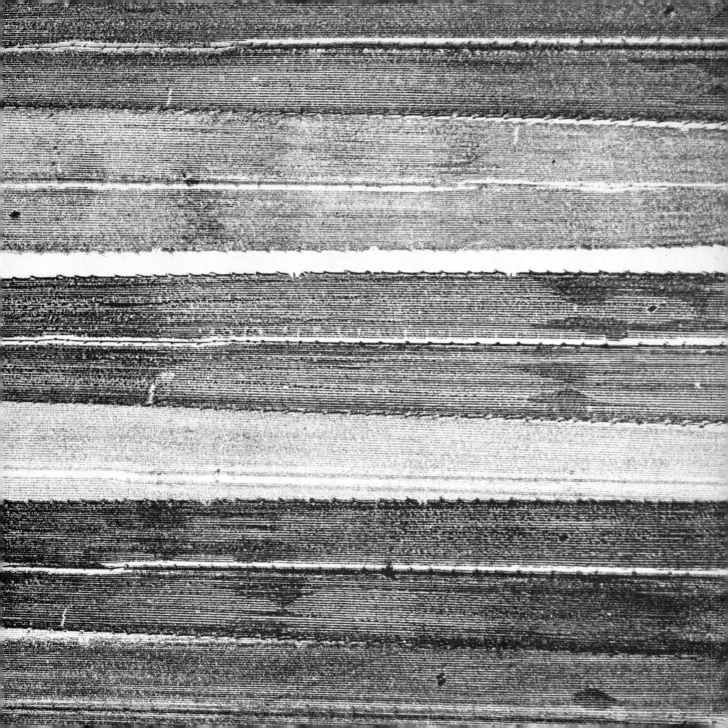

Prints from man-made objects

It is not intended here to compile a list of print materials which fall into this category, as they are limitless. Instead, here are a few suggestions with notes on how the objects might be printed.

First, ordinary household items such as odd buttons, scissors, needles, sewing thread and small pieces of fabric. To print from any of these objects which has an uneven surface, the same principle applies as to the feather print in the last chapter. After inking the object, place it on a flat pad of paper. A soft type of roller will be needed to ensure that all the surfaces will take ink. Scissors should be inked separately on a table, not on soft padding, and slid off the base card on to the bed of the press. Prints can then be taken either by press or hand. In the press, a good soft padding should be placed over the object and pressure applied gently. After some practice it will be easy to judge the exact amount of pressure required.

The alternative method described in the last chapter for printing natural materials is also very successful in this case – coat the object with ink and take a pressure print slowly. Then turn this on to the printing surface, cover with paper and roll. With the type of material we are discussing, flat, hard packing will be required.

Buttons printed in this way, ie a hand pressure print,

and later set off on to the final print paper, will produce an image a little paler than the first proof.

Prints are shown here from a single piece of string with a series of variations. In this instance only two colours are shown in tones, but it is clearly only a matter of time and patience to print a similar theme in a large number of colours.

A folded paper boat of the most simple form is shown with variations on the original theme.

These can take many printings, and the paper or thin card used becomes stronger as the process continues. It is possible to clean paper used for printing by removing ink from the surface by several offsets from the paper. It will, of course, remain stained, but the stain will not print, neither will it affect colours which might be used later.

Prints can be made from the bases of saucers, glasses, and eggcups by the simple process of rolling ink over their bases or pressing them on to an inked slab and then re-pressing them on to the printing paper. Obviously, several colours could be used in a design pattern made in this way, associated with prints from string, linen or any other suitable item.

A piece of crumpled paper makes a print which is quite unpredictable, and here again, a complex of associated themes provides ideas for more ambitious processes.

It is important not to put in a press or under board pressure a collection of objects, natural or man-made, which have too great a variation in thickness, or some may not print at all.

A curved object such as a cheese grater, with a variety of perforations, can be printed by being rolled on a thickly inked slab, and rotated on to the printing surface with a rocking motion, slowly and with constant pressure.

A stiff ink with little running property is required to obtain an impression from delicate marks, such as a marked scale or a trade advertisement engraving. The use of kitchen utensils need not stop at the printing of the surfaces. Actual cuts and scratches can be made in lino or soft wood by a number of unusual tools from the kitchen.

String print with roller pressure

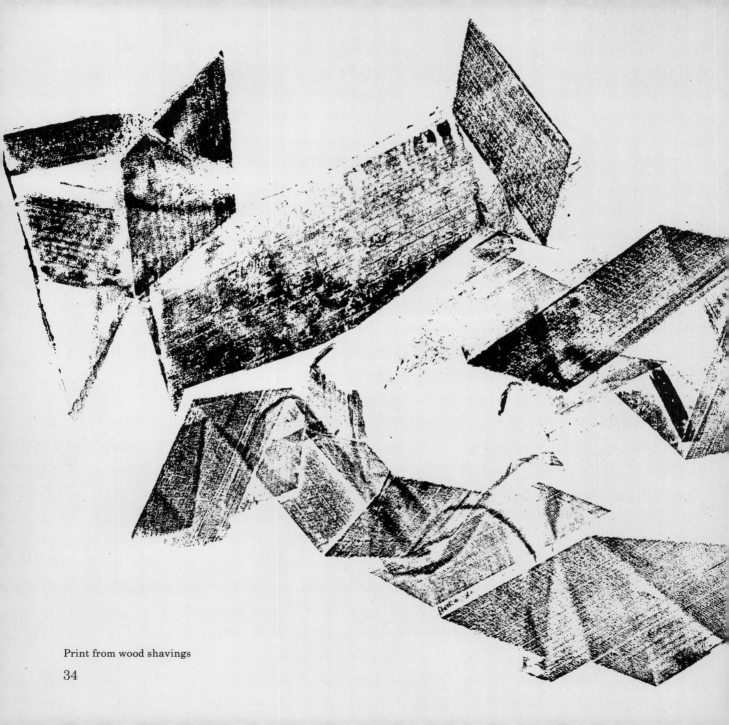

Print from wood shavings

34

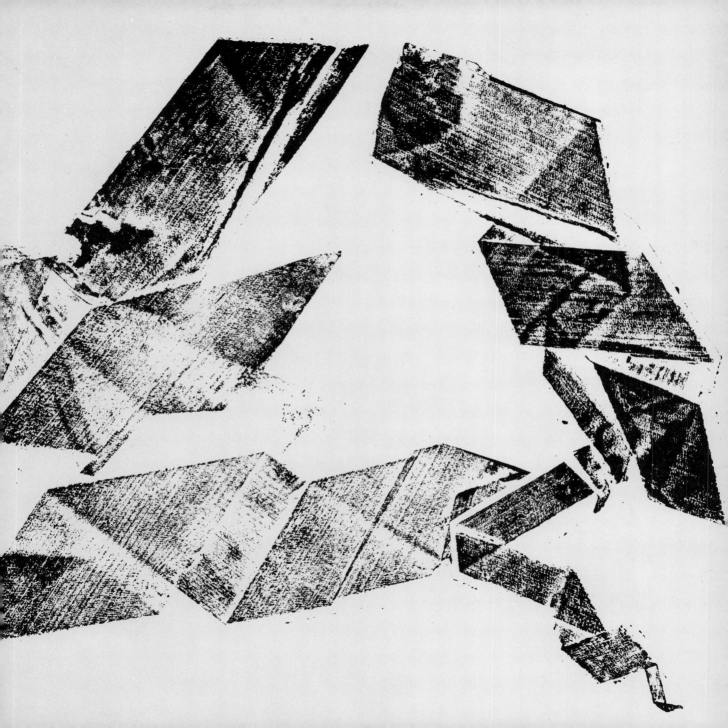

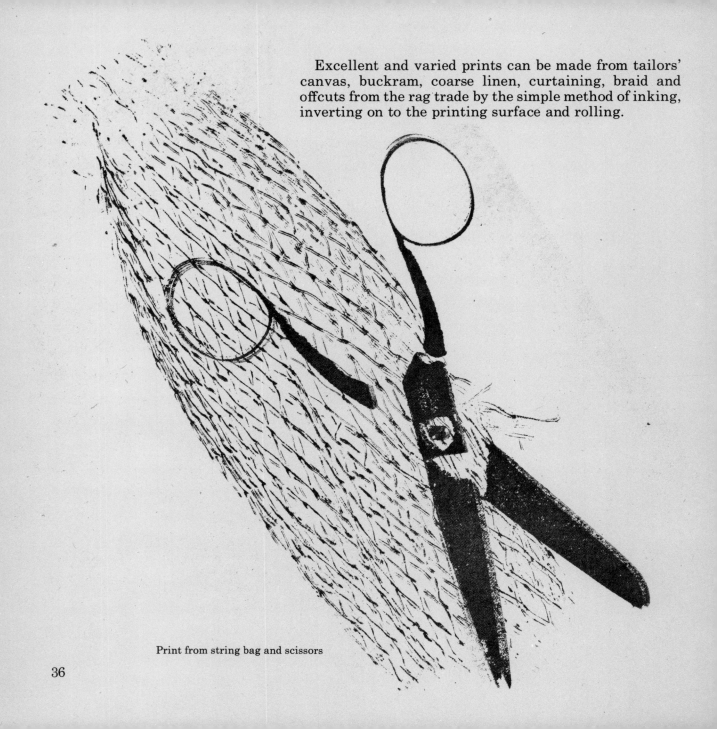

Excellent and varied prints can be made from tailors'
canvas, buckram, coarse linen, curtaining, braid and
offcuts from the rag trade by the simple method of inking,
inverting on to the printing surface and rolling.

Print from string bag and scissors

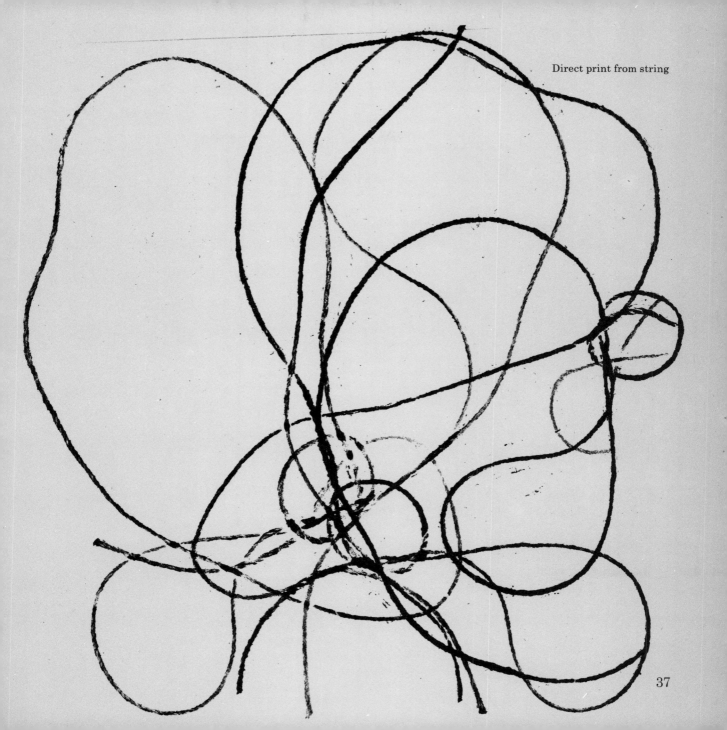

Direct print from string

37

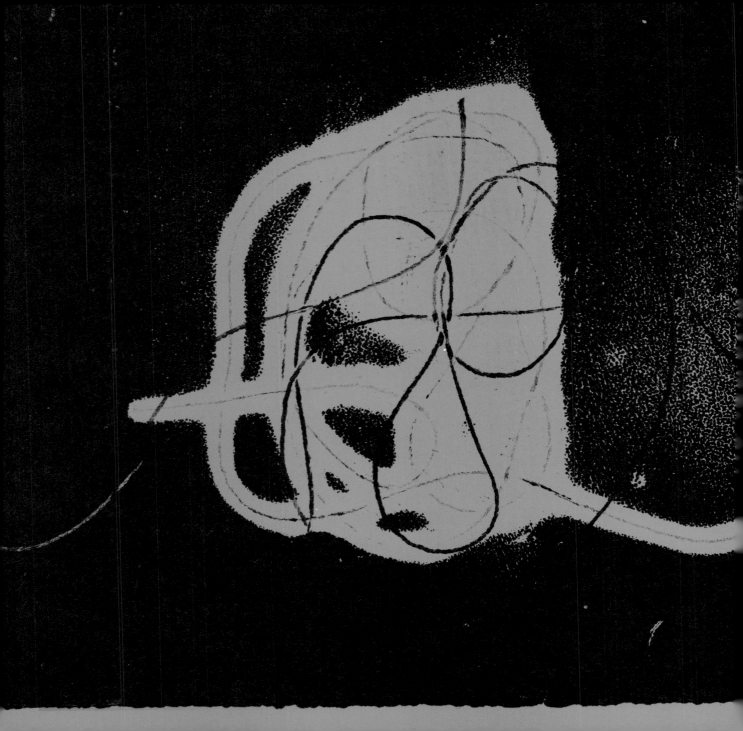

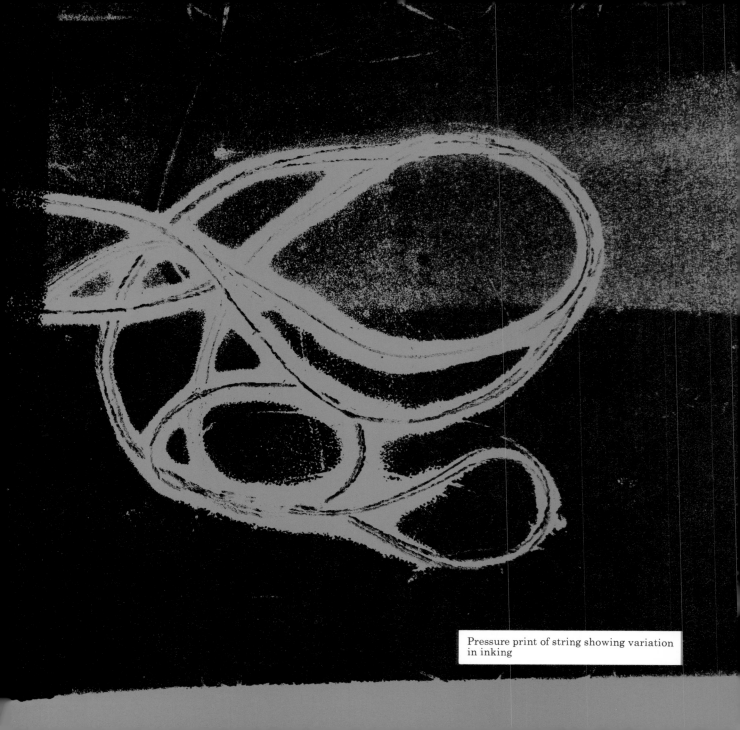

Pressure print of string showing variation in inking

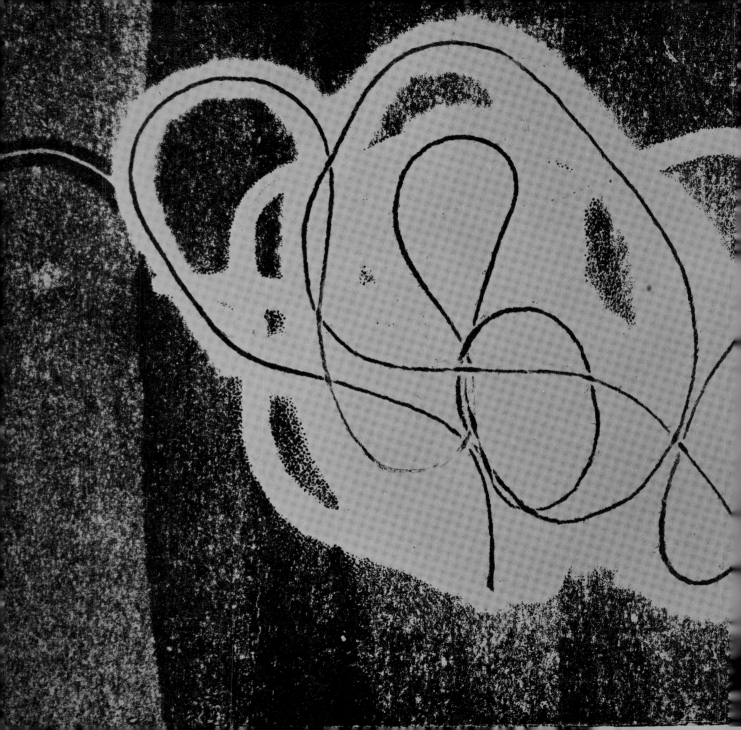

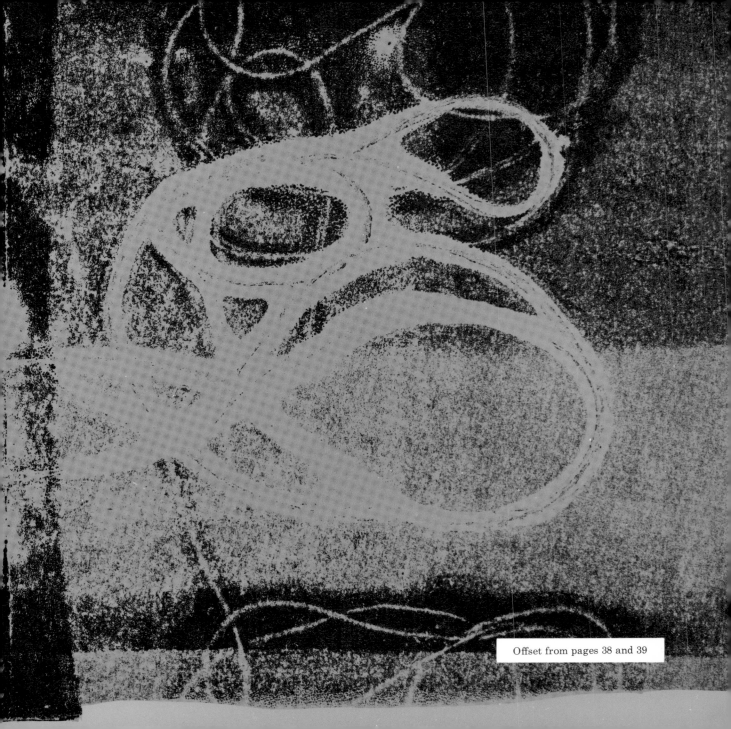

Offset from pages 38 and 39

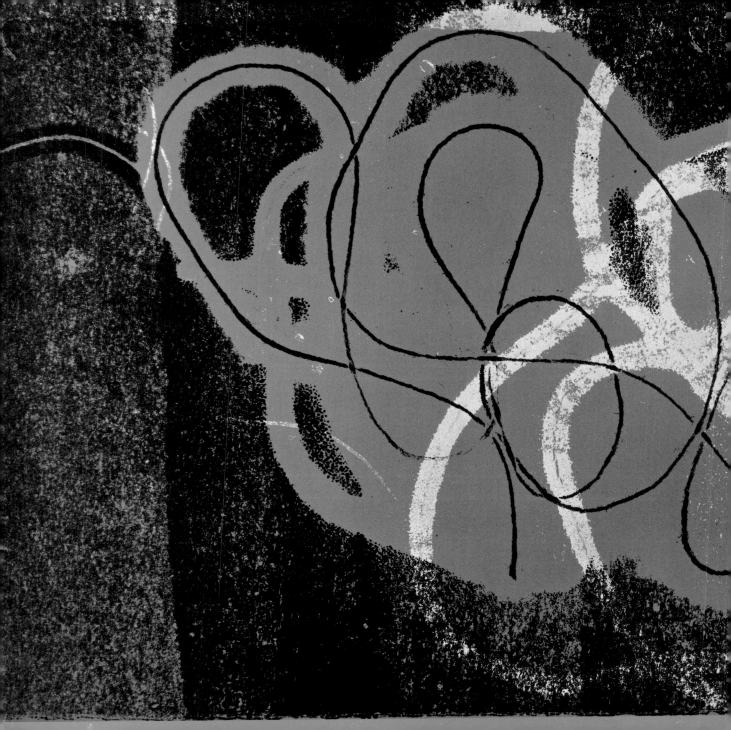

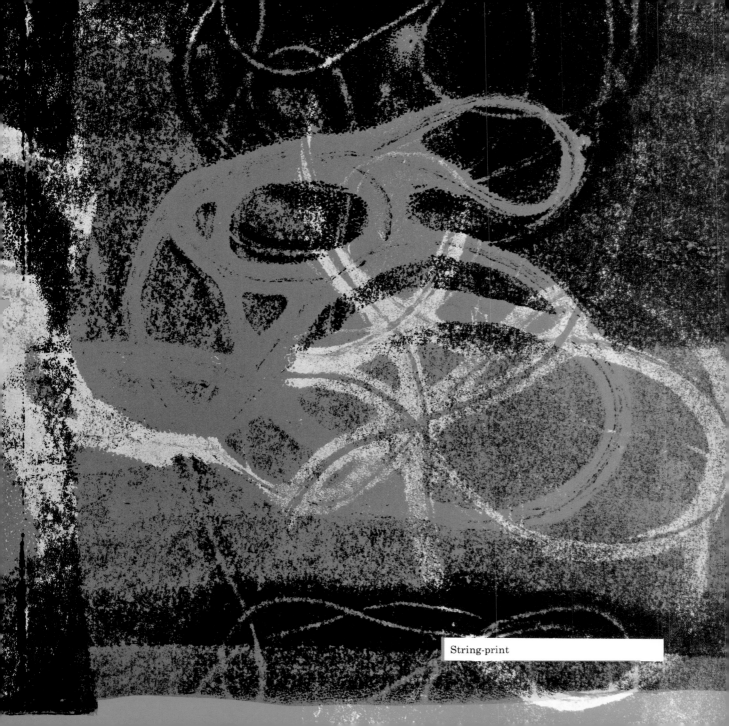

String-print

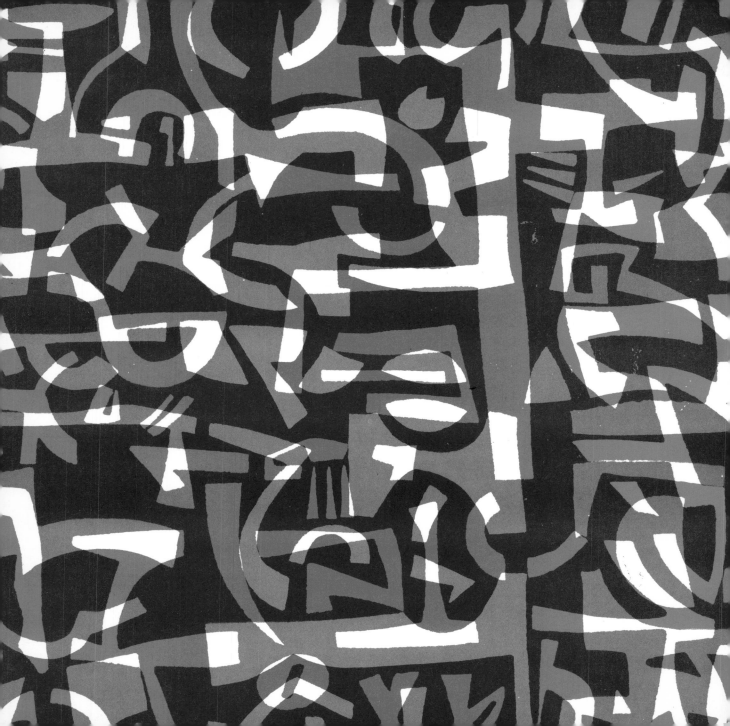

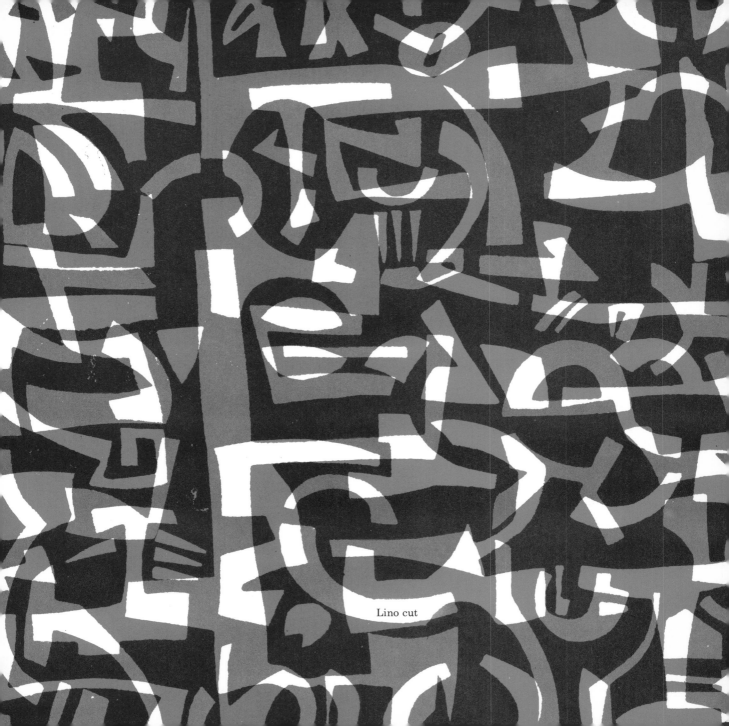

Lino cut

Direct print of a paper boat

(opposite) Offset print of a paper boat

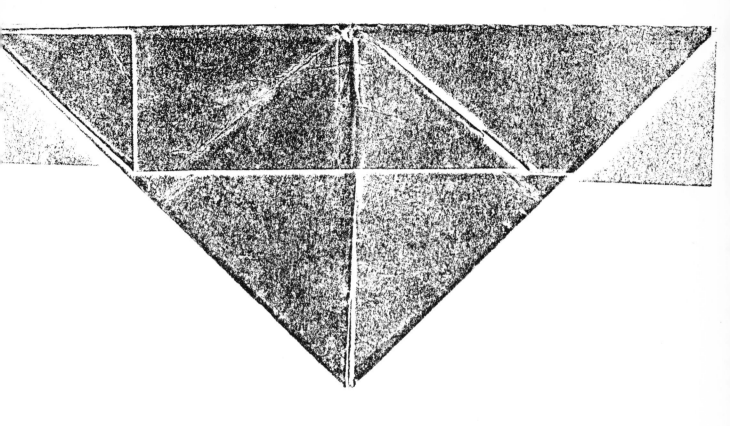

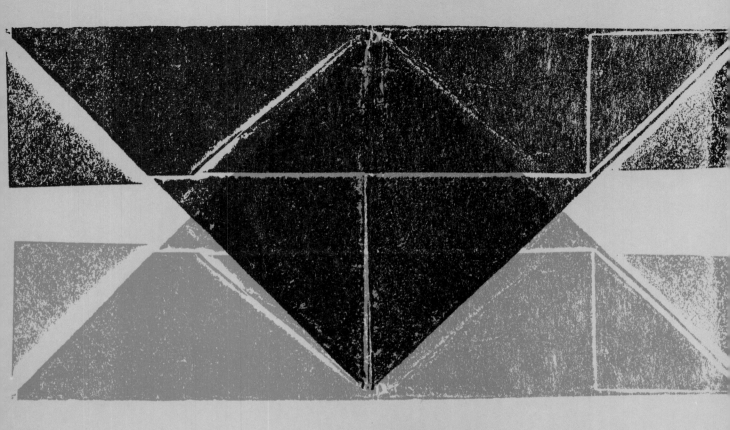

Two colour offset print of paper boats

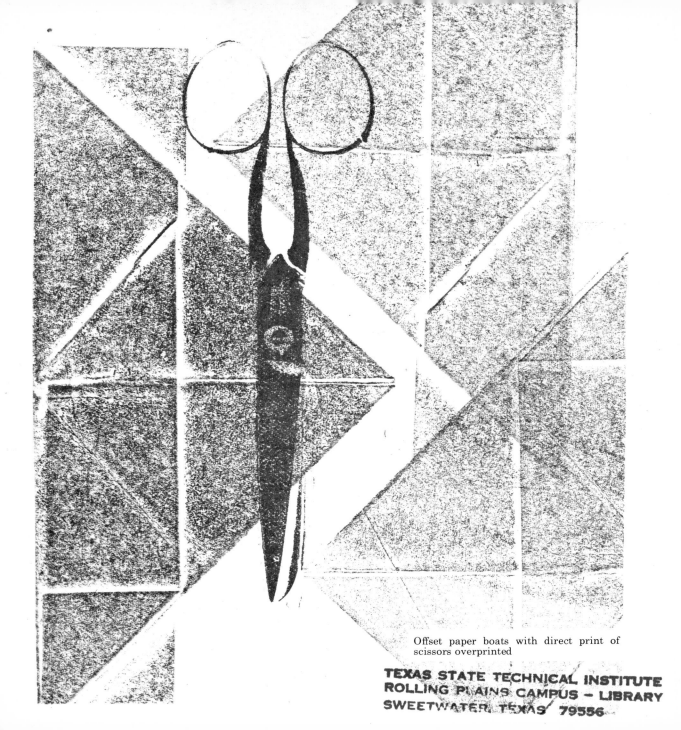

Offset paper boats with direct print of
scissors overprinted

Direct print from a paper plate

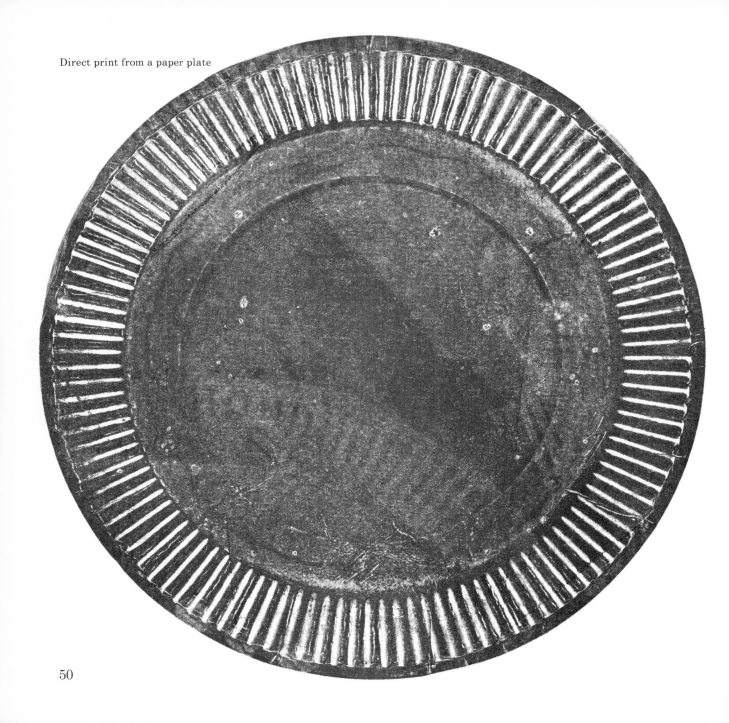

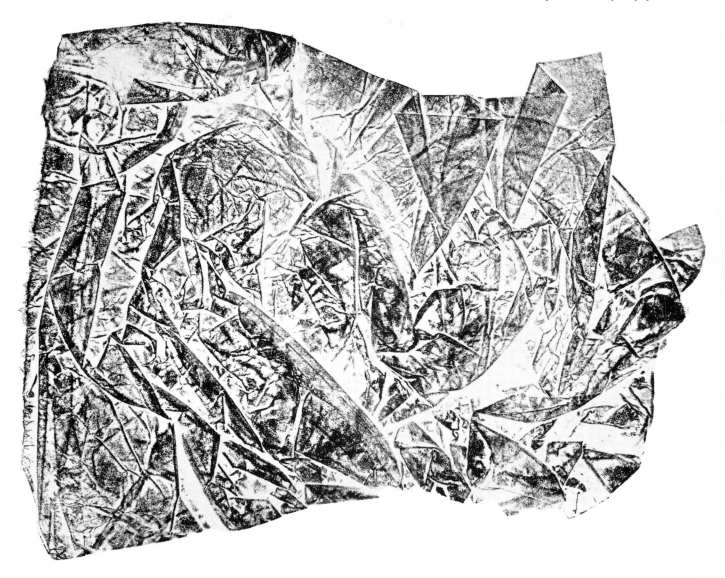

Offset prints of metal foil plates on a tinted
background

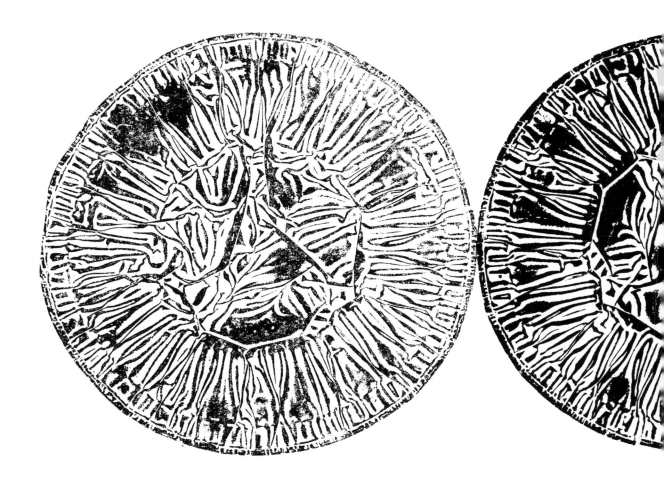

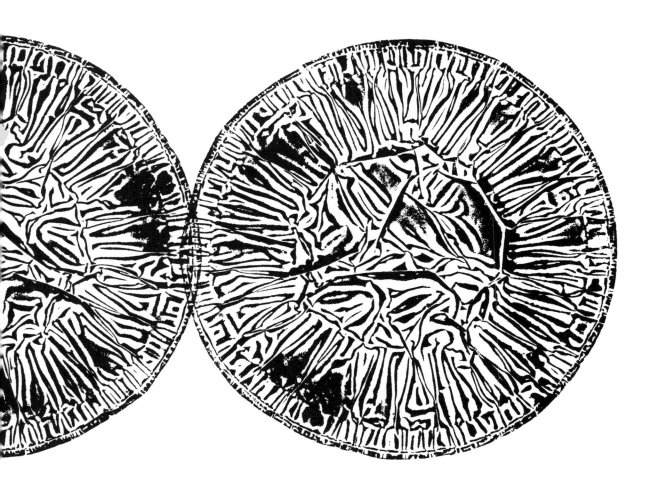

Papers, inks and pigments

Papers A print can be taken on almost any paper, but the best are those which absorb ink, dry quickly, and retain their original whiteness or colour.

There are excellent Japanese and Indian papers ranging from very thin to very strong. The former is a tissue so thin that it has to be 'floated' on to the block, where it takes up ink without pressure, and is in this sense almost self-printing. The latter is as heavy as thick watercolour paper, absorbs a good deal of ink, and dries almost immediately after printing.

Hard-sized paper which has a washable surface, and consequently poor absorption, is used only with inks chemically prepared to dry by evaporation or internal chemical action. It is most useful in making a special type of hard-edge print in which the ink remains remote from the paper.

Hard papers can be damped between blotting paper and stainless tin sheets or by sweeping strokes with a large wet sponge. They are, or course, quick drying. A very thin layer of ink is used, and this may be removed by the 'printing off' process (see page 45).

Plenty of paper is needed with which to experiment. Small commercial printers usually supply this cheaply.

Inks and pigments Inks and pigments used in hand printing are of two main types:

1 Water or glycerine-bound, such as watercolour inks or paints supplied in pots or tubes, acrylic paints, and plastic inks soluble in water.
2 Oil-bound inks like those used for trade printing by letterpress, lithography, and oil dyes used for fabric and textiles.

The two types of ink must not be confused. Separate rollers must be used for the two categories of ink, as cleaning off oil ink with solvent will prevent the roller taking up water-bound ink. A special trade solvent can sometimes toughen the impaired surface of rollers which may be required to print a very clear woodcut or engraving.

When printing from uncut wood, planed soft or semi-hard wood, blockboard (chipboard), or card, it is necessary to carry a good quantity of ink with wide rollers, 100 mm (4 in.) diameters, and this quantity of ink would be difficult to maintain with the water-based type.

Ordinary oil paint can be used as an ink if rolled up smoothly and cleaned with a white spirit solvent. Other paints for artists' use, bound in any medium other than oil, should be cleaned in water or in the solvent recommended by the manufacturer.

Letterpress ink is supplied to the printing industry in very large quantities, and a small firm will often supply a small quantity from the proofing department where small quantities are used for the colour testing and machine proofing of a few dozen prints in preparation for a commercial run.

Artists' materials shops will supply oil-based inks in tubes or tins, black, white and coloured, which vary considerably in price according to colour and quality. The use of inferior inks is a false economy, as they will not give a true image from the block or other material from which the design is produced, and the result will be most disappointing.

Storage of inks Inks should be stored at a constant temperature. Tins must be stood upright and screw tops must always be replaced on the tubes as some tubes, being filled under pressure, will empty in an hour or so if left uncapped, and in less than an hour if laid flat in store or on a working table.

Any ink put out for use and not needed until the following day can be kept if scooped up with the palette knife into an airtight plastic or strong paper carton. For re-use, the outer skin which will have formed must be neatly removed and only the clean ink used for rolling up on the slab.

Storage of paper Paper on which prints have been taken and which must wait for a day or two before handling can be stored in a ceiling rack. These are obtainable from the trade at a variety of prices (enquiries should be made at a local artists' colourman store), but a substitute or temporary rack can be made by stretching a nylon indoor clothes line from two opposite points above the work area about 1·8 m (6 ft) from the ground if there is plenty of floor space or, if there is only limited space to move about in the workshop, it should be about 60 cm (2 ft) higher. Spring loaded plastic or metal clothes pegs can be used to hold the prints on the line. An easier method is to have two lines, so that the prints can be hung at right angles to the nylon cord, with two pegs for each print, but care must be taken that the pegs do not damage the prints.

Wood engravings, woodcuts and multiple blocks

Wood engraving The best quality in all wood engraving is the clean, sharp reproduction of the cut line in the print.

Wood for engraving is a section cut across the grain, as from the tree or joined together in small pieces of about 75 mm to 100 mm (3 in. to 4 in.), in rectangles. The working surface must be made accurately level, and thick enough to prevent warping, that is about 25 mm (1 in.).

The cutting tools have been described in an earlier chapter. They should be held in the most convenient position in the palm of the hand and the block rotated towards the cutting point, or the cutter moved gently into the surface of the block. For ease of cutting, the elbows should be locked on the working table, allowing the hands to move freely, using the thumb as a cutting guide along which to move the cutter. This will prevent the cutter from slipping on the block surface. Always cut away from the hands. Keep the cutters very sharp by frequent gentle rubbing on a Turkey or Arkansas hard oil stone.

Although box is undoubtedly the best wood for engraving, it is not necessary for many printing projects. Pear, apple, hornbeam and maple woods may all be used with very good, clean results. Do not use very small blocks for engraving, as they can be tedious to cut, and

are certainly difficult to handle. If small units are required, the whole set can be cut on one large block, as the trade engravers of the nineteenth century used to do, and cut up afterwards, or separated when in print form.

Small detailed lines can be made in the same area of a block as broad scorper lines, but these should not be made too close together or bad printing will result. These lines may be crossed, but the crossing must be made as near to a right angle as possible in order to prevent the wood texture from breaking up and destroying the surface. Large white areas may be masked, and different colours used on the same block in several areas of wood for one impression.

The use of multiple cutters reduces the time taken in making a wood engraving. Crosshatching with multiple cutters is not advisable, except in rare instances in very clean lines on a rather hard wood, such as medium boxwood. Tone made by the use of multiple cutters is a useful foil for the area of single thin or bold lines in a design. Black, untouched lines will be found to lend character and body to multicut pieces of the work.

A wood engraving block can, of course, be divided into any number of collectively used blocks, printed separately or in the same impression, rolled up in a variety of ink colours, with or without masking.

It should be noted here that prints can be made from images scratched in scraper board, using a stiff ink and a hard roller, but there is no real substitute for cutting on wood, and prints thus made will have a thin and unpleasing appearance.

Woodcutting The V and U gauge cutters used for this process are sturdy and durable, but the technique of using them is a delicate one. A sharp edge is essential, and this is maintained by the use of a thin, leaf-like stone called a *honing stone*, which is held in the palm of the hand by the thumb and first finger, and honed up and down the groove of the steel.

The cutting is done by a gentle pushing movement

Trade engraving

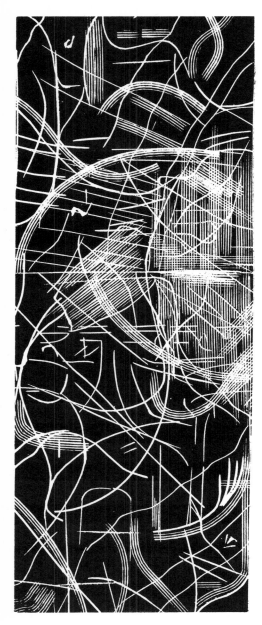

away from the body, or by rocking the cutter with short, firm movements towards the body. For the latter technique, the hand and wrist should be held in a constant position, and the blade directed as required into the wood. You will soon find the manner of cutting most suitable to your own hand and eyesight. For a print from wood, clean and deliberate cuts should be made, as frayed edges of wood remaining untrimmed will pick up unwanted ink and cause untidy edges. The cutting is not so easy as with lino, but it does impart a sturdier quality to the work.

A short bladed, very sharp knife can be used to good effect on plank wood, (wood cut parallel to the tree trunk) in conjunction with the V and U shaped cutters. Prints can, of course, be made from wood which has not been cut at all, or possibly with some hand or machine cut sections.

A student is often pleasantly surprised by his first wood engraving print, but disheartened by that from a woodcut. This is because he has not allowed for the quality of the wood asserting itself. The end grain used in wood engraving is certainly more expensive than natural plankwood, blockboard (chipboard) or lino, but the work will be of a richer quality and will have characteristics unobtainable by any other process.

Do not be discouraged by an apparently unsuccessful first proof. A printmaker will often modify his original concept after proofing, thus arriving at an experimental and unplanned basis for continued working. Perfection can be very dull in print, although often desirable, whereas an extension of a design suggested by an otherwise rejected proof can add considerably to the final theme.

Linocutting Linocuts are in effect the same as woodcuts, the main difference being that lino does not offer any natural surface, nor is there any grain to make use of or avoid in a design. Like wood, lino can be cut up jigsawwise, and reassembled in multiple sections, and can be

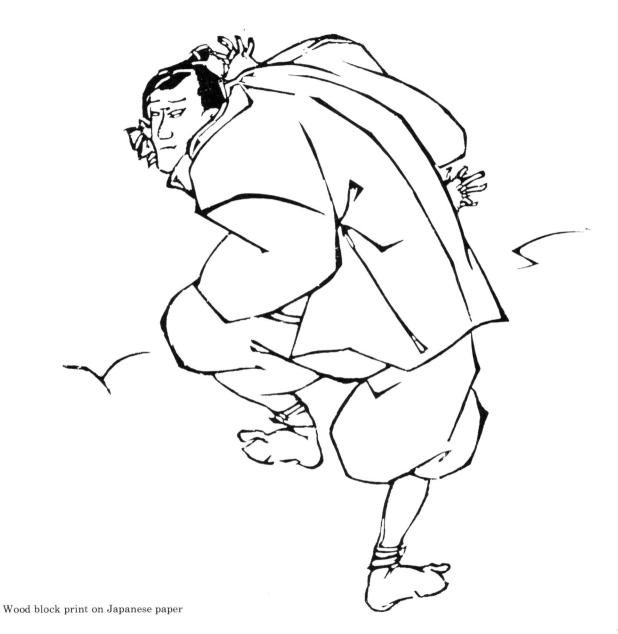

Wood block print on Japanese paper

61

used in association with other media or other kinds of printing surfaces with more than one printing impression. It does not matter if the blocks are of different heights, as adjustments can be made by packing in the press.

Linocutting is easy and although, generally speaking, the technique is the same as for wood, there is a finality in the cutting that makes it a satisfying thing in some ways, but if a strong and sturdy quality is required in the print, wood is the better medium. Only by the acquisition of considerable skill and experience is it possible to equal the natural attraction of the wood grain and surface by careful management of the colour disposition, bleaching and ink starving, on a linoprint surface.

As there is no innate quality in lino as there is in wood, the density of the ink used in printing becomes of prime importance. A linoprint, like a woodcut, may be deliberately underinked, but it will probably not retain its quality in starved printing as a woodcut does. Conversely, ink or pigment may be painted on a linoblock, but in this case there must be a longer interval between printings, because of the non-absorbent nature of the material.

Woodcut ▶

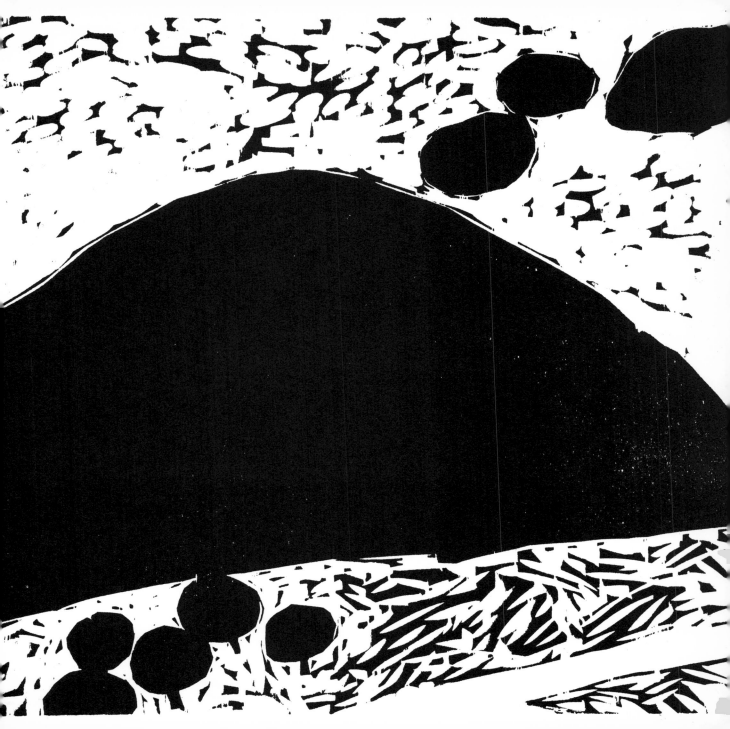

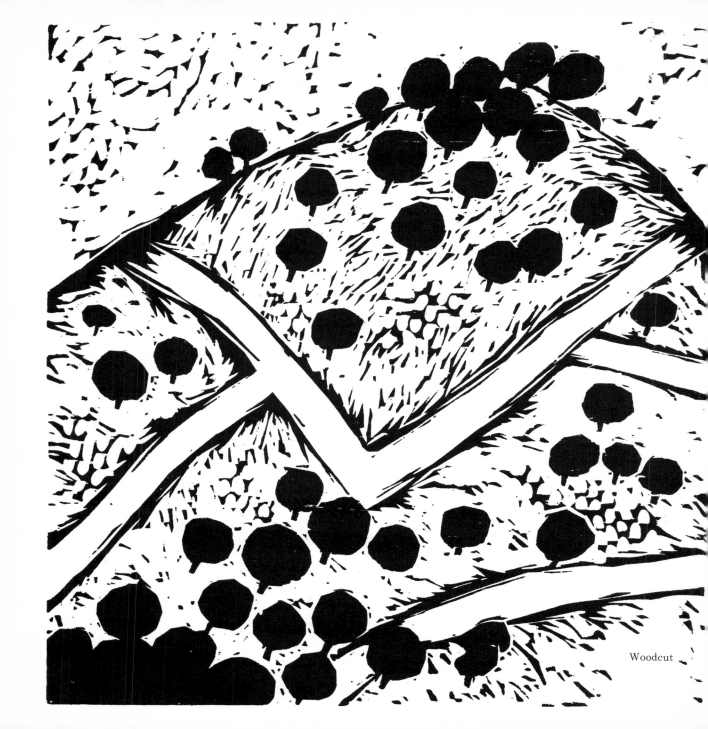

Woodcut

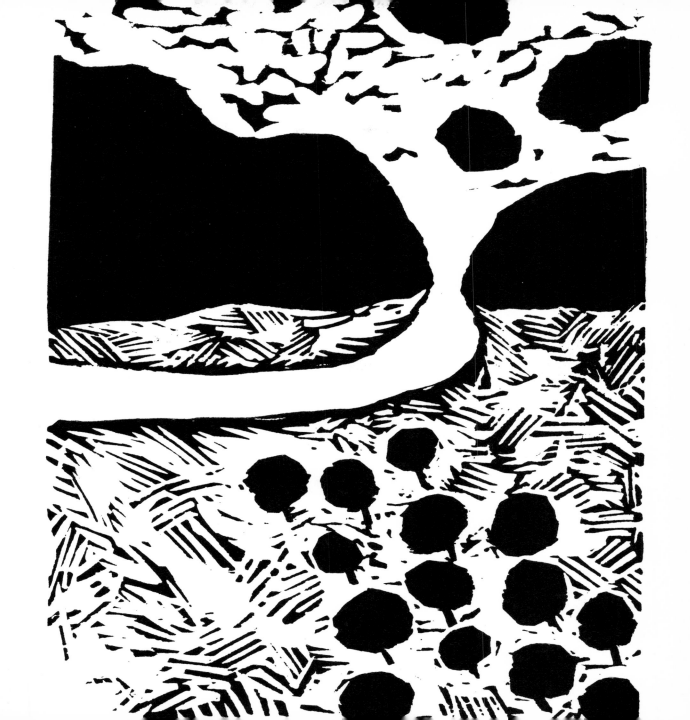

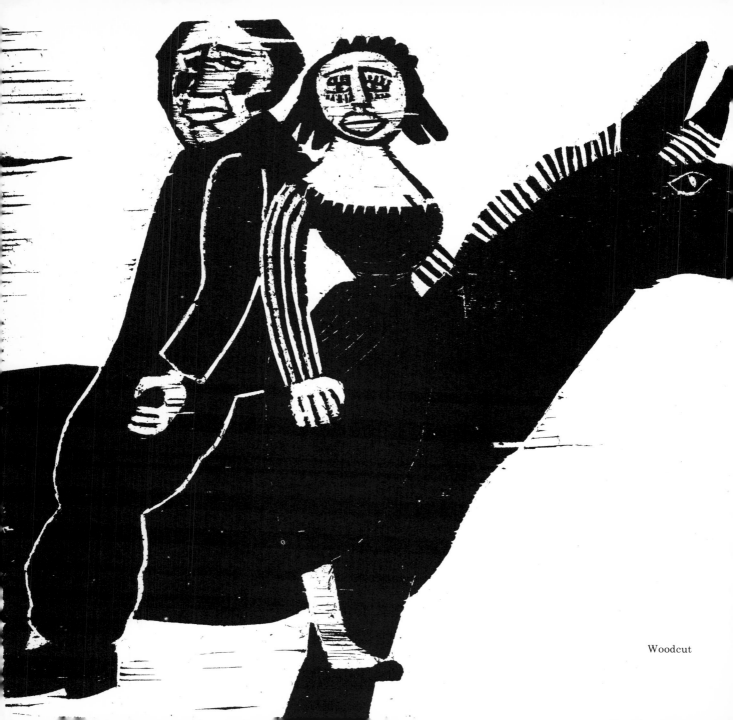

Woodcut

Multiple blocks The print shown on page 86 has been made by letterpress, from a block which has been built up on a small piece of hardboard with quick-drying resin; any plastic material with mobile qualities will do for this work. This print was made with one layer of the material only. It could easily be continued with a further application of the pattern.

As with blocks or paper, these prints can be in different colours. Although the print here has been made from board-mounted resin, it is not necessary to use either card or board, for strong paper will do equally well. Natural objects can be added to this material for further prints, and overprinted in a variety of colours and tones.

There is no limit, except time and paper, to the organised variations possible in this manner of printing. A built-up block can be easily made anywhere, and if more than one is made, it is possible to ring any number of changes on a printing theme.

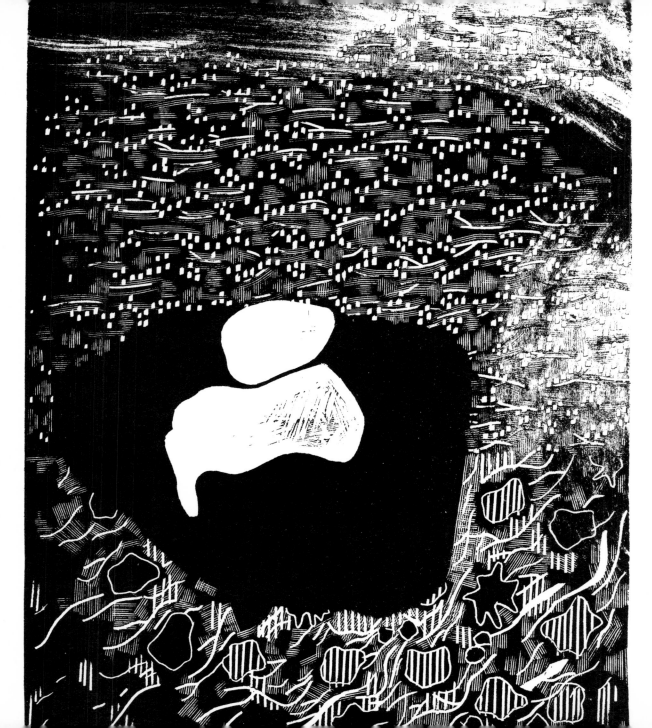

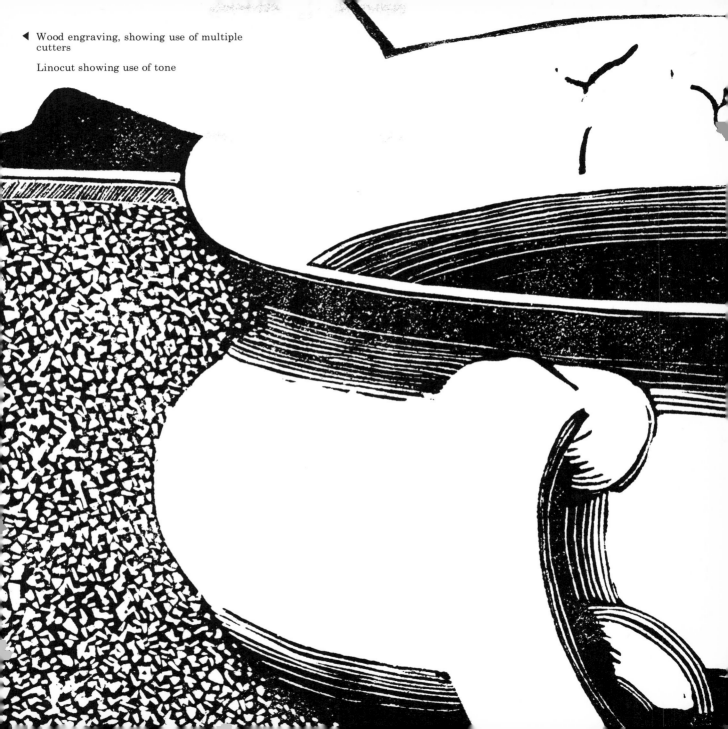

◀ Wood engraving, showing use of multiple cutters

Linocut showing use of tone

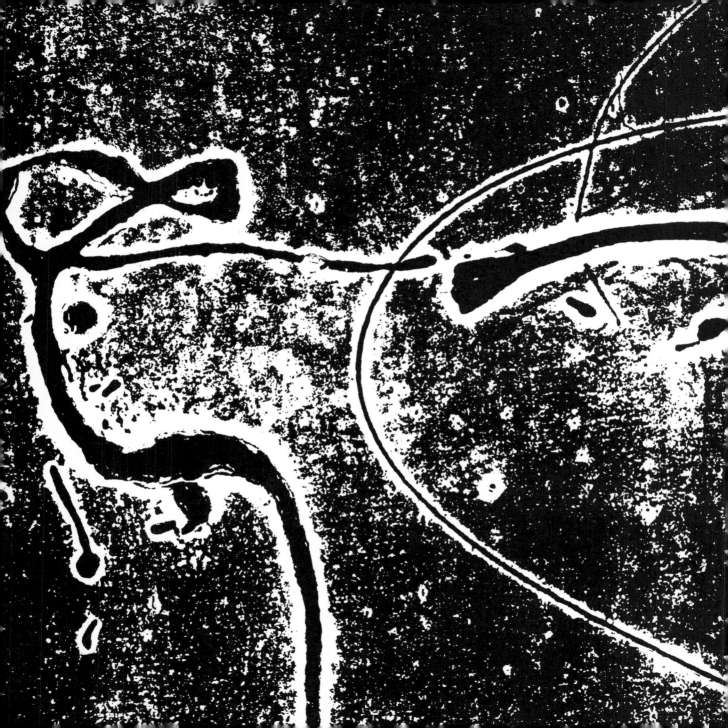

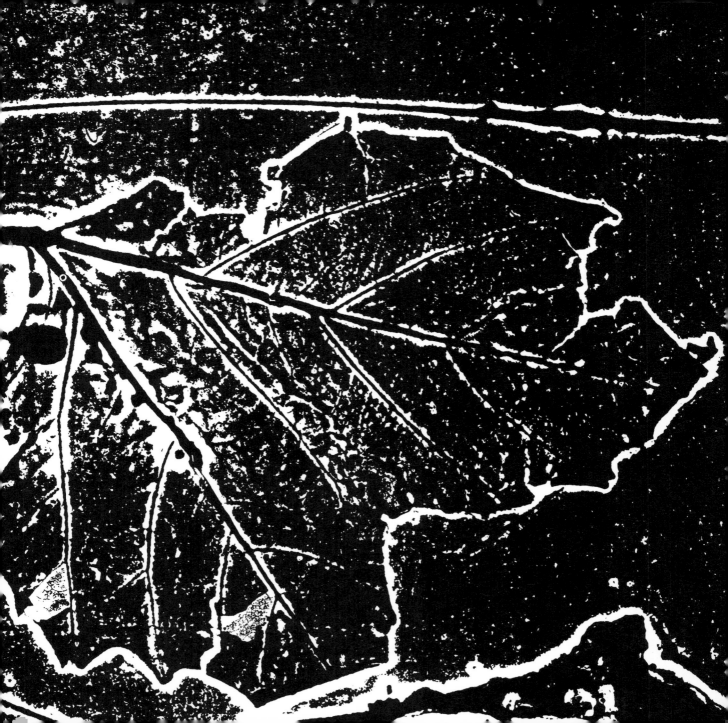

Linoblock A

Linoblock B

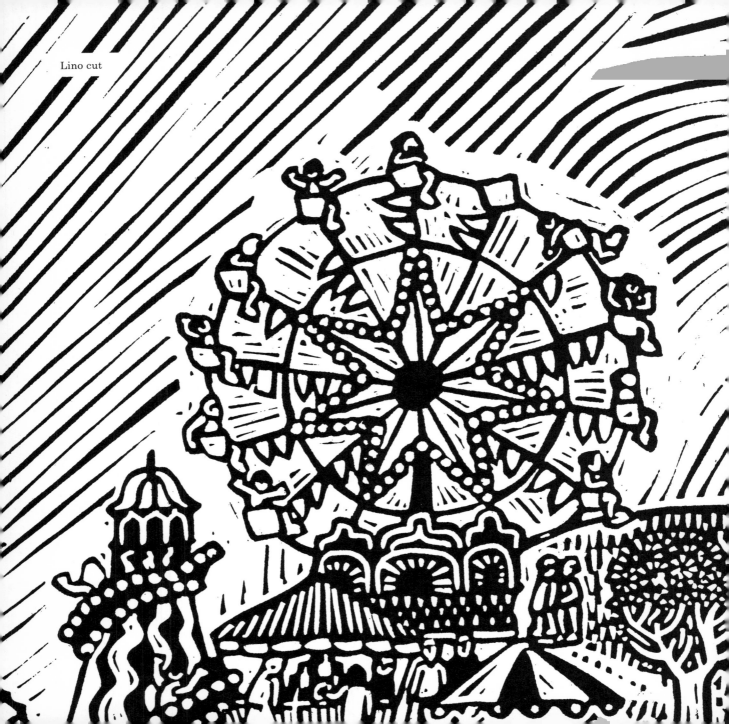

Lino cut

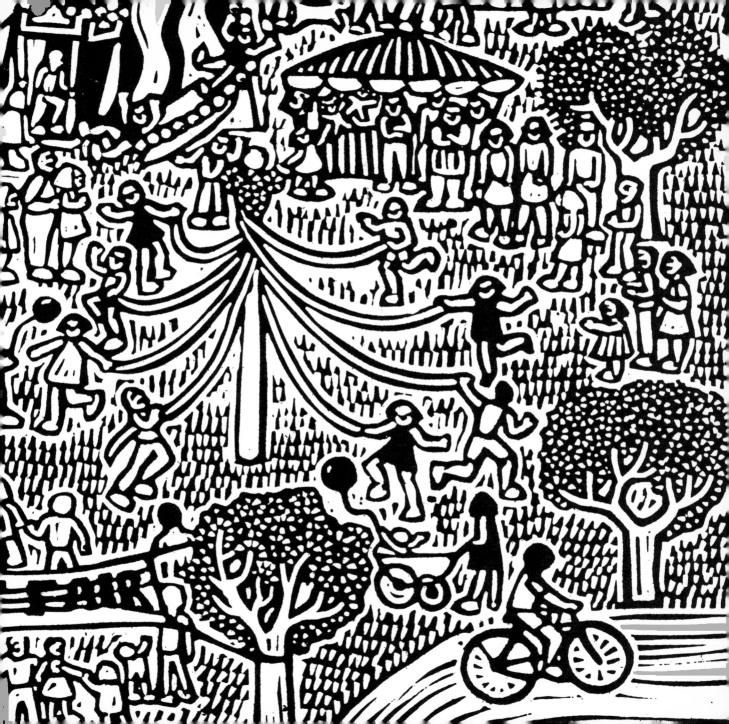

Linoblock A

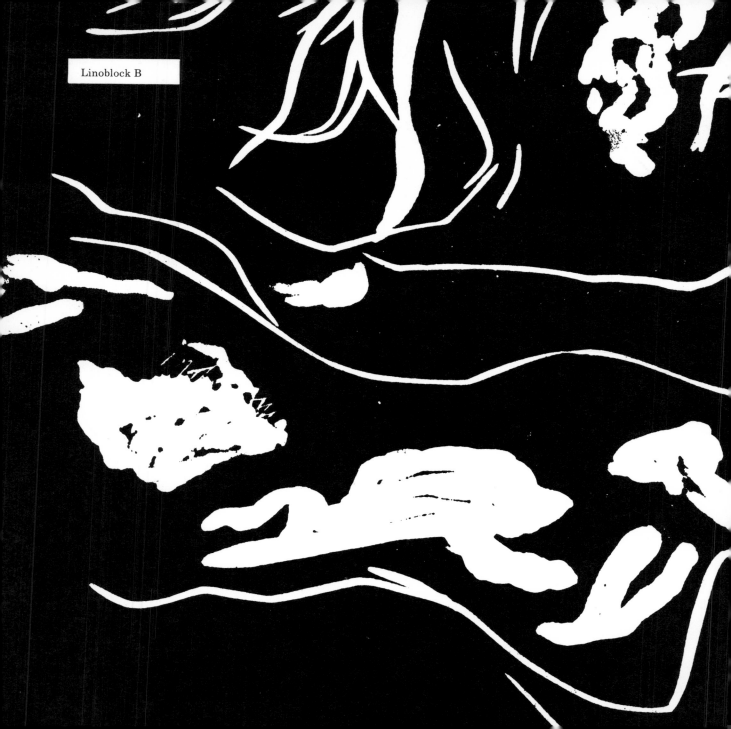
Linoblock B

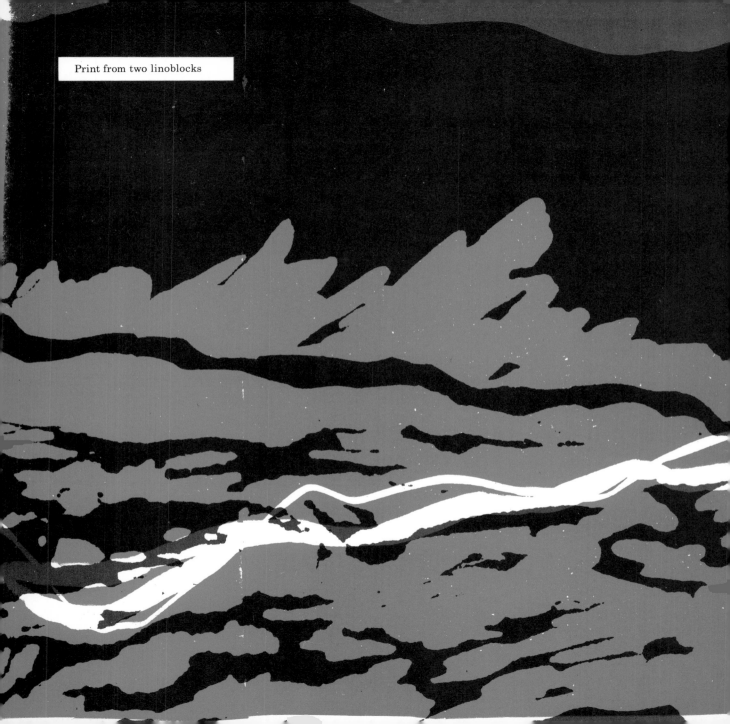

Print from two linoblocks

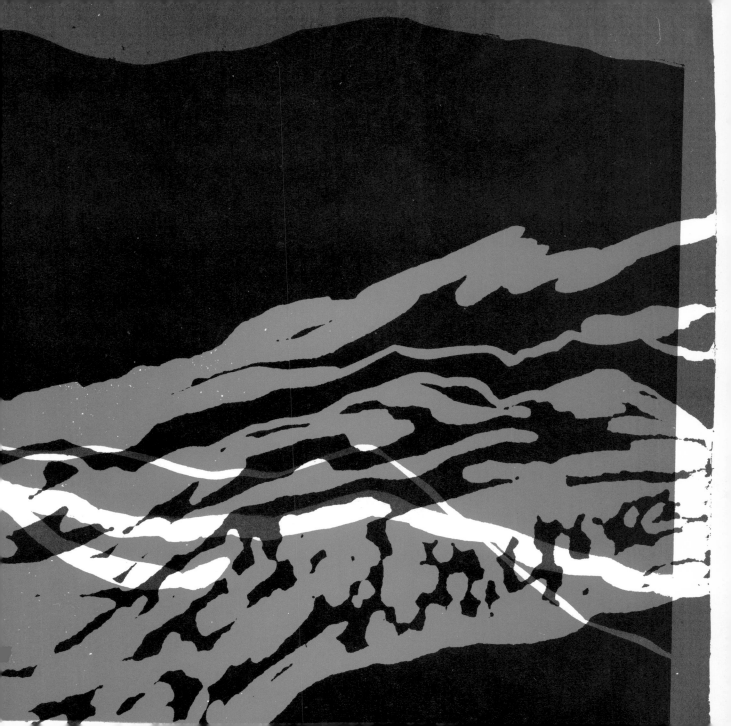

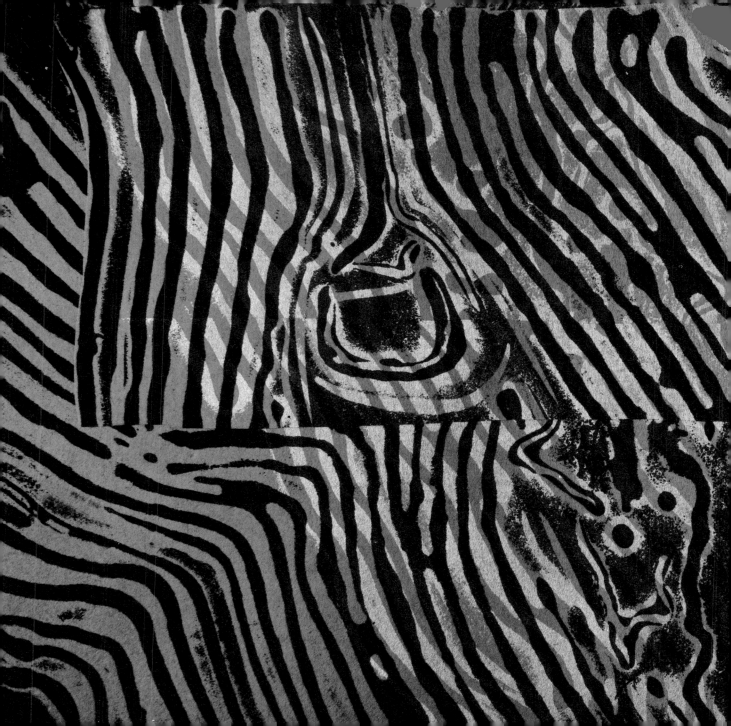

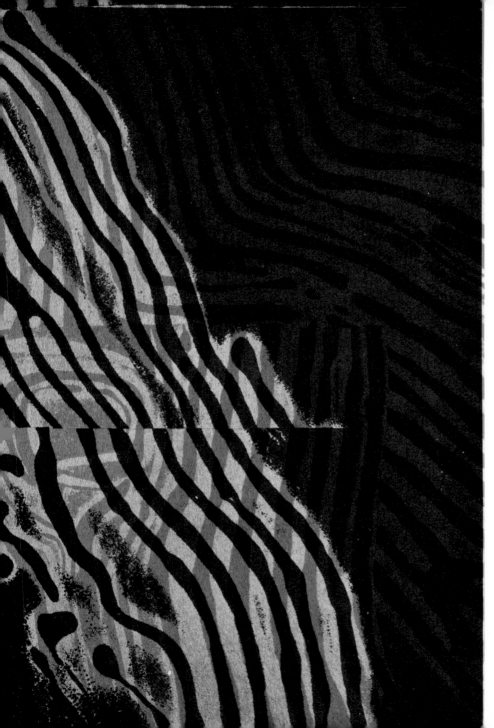

Paper
and card prints
and collage

Probably the most direct way of making a print is by rolling a piece of strong paper or card with ink, placing another piece of paper over it, and taking an image by press or by the burnishing method.

If a card is torn or cut into a planned shape and proofed in this way a print of the shape will result. By placing a second piece of card or paper already inked in a different way over the printed surface, a further and more complex print, in three tones of colour, can be made.

It will be seen that any spaces made in the first and second pieces of paper will allow the original paper to show, untouched by the first or second printings. Thus, a design will occur which shows, for example, plain paper in the centre, with two or three colours around this. Card may be printed and reprinted without re-inking, to produce monoprints which are paler in tone, as the amount of ink is reduced with each print. The unpredictability of these instant prints is one of the important features of all experimental printing, as opposed to an edition of similar prints made by the orthodox method of taking proofs, finalising the image and repeating it.

The prints on pages 90 to 103 show a sequence of proofs from torn paper or card. In the printing trade, the term 'card' is used to describe thin material which is little thicker than a postcard, but the thickness does vary

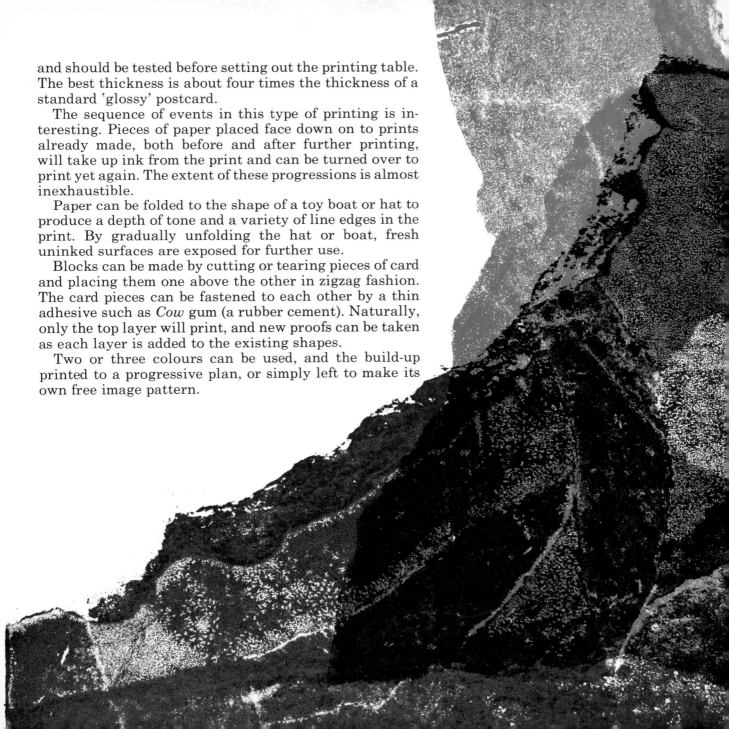

and should be tested before setting out the printing table. The best thickness is about four times the thickness of a standard 'glossy' postcard.

The sequence of events in this type of printing is interesting. Pieces of paper placed face down on to prints already made, both before and after further printing, will take up ink from the print and can be turned over to print yet again. The extent of these progressions is almost inexhaustible.

Paper can be folded to the shape of a toy boat or hat to produce a depth of tone and a variety of line edges in the print. By gradually unfolding the hat or boat, fresh uninked surfaces are exposed for further use.

Blocks can be made by cutting or tearing pieces of card and placing them one above the other in zigzag fashion. The card pieces can be fastened to each other by a thin adhesive such as *Cow* gum (a rubber cement). Naturally, only the top layer will print, and new proofs can be taken as each layer is added to the existing shapes.

Two or three colours can be used, and the build-up printed to a progressive plan, or simply left to make its own free image pattern.

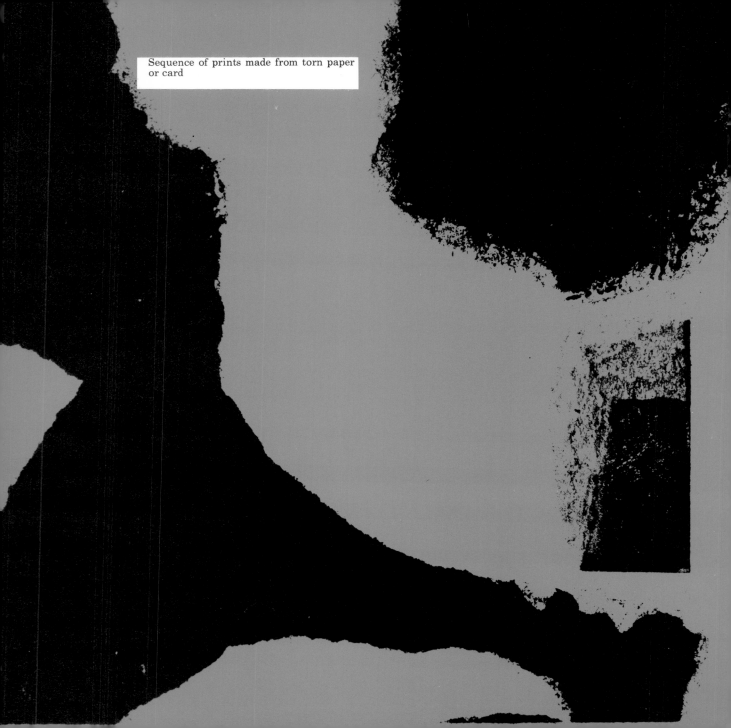

Sequence of prints made from torn paper or card

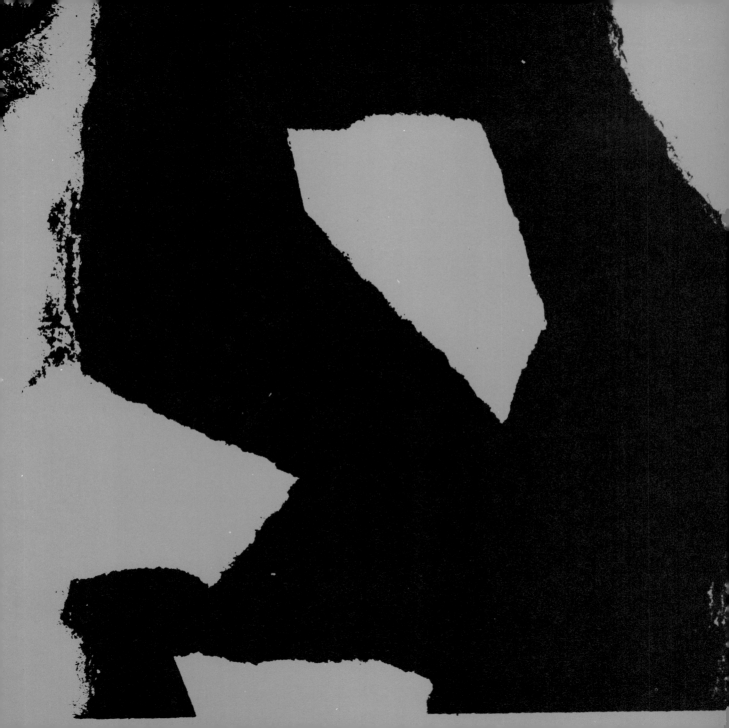

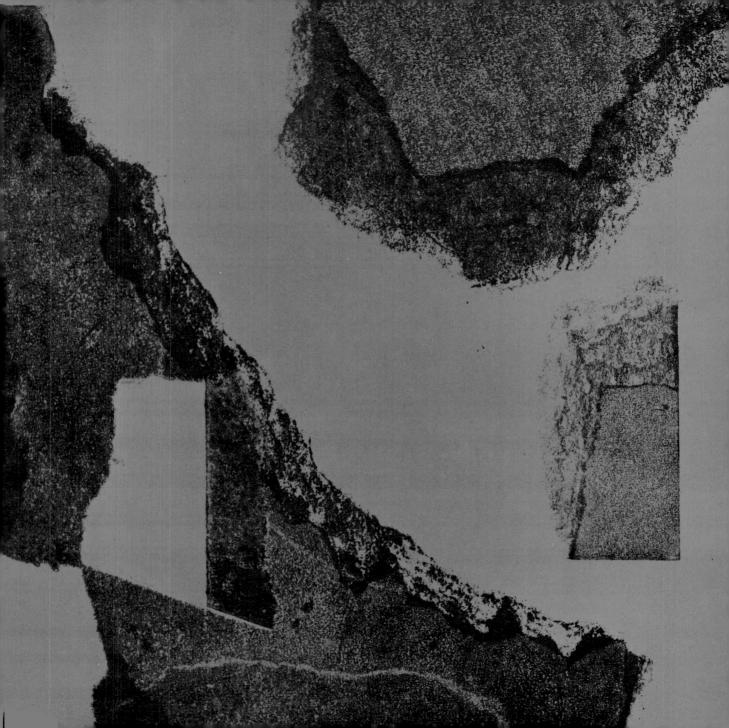

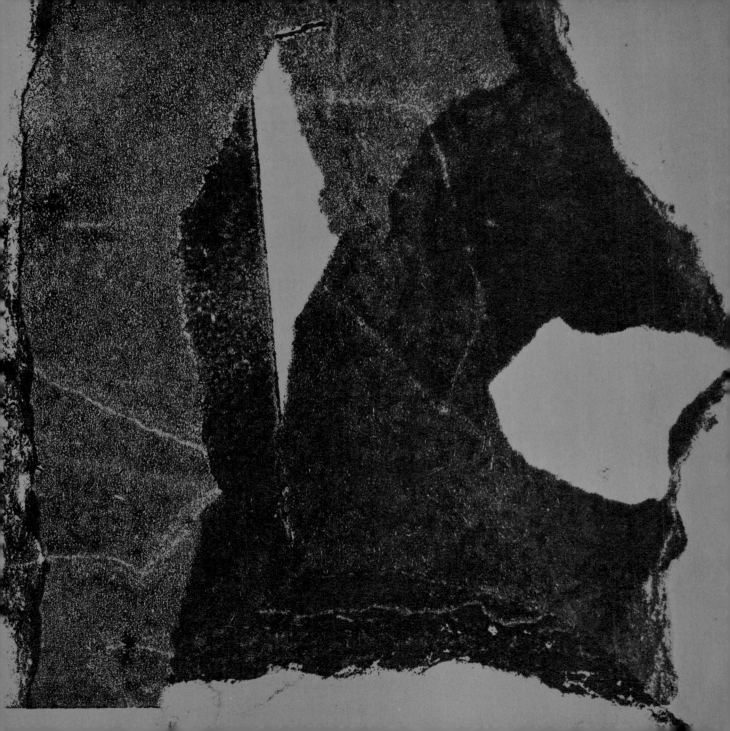

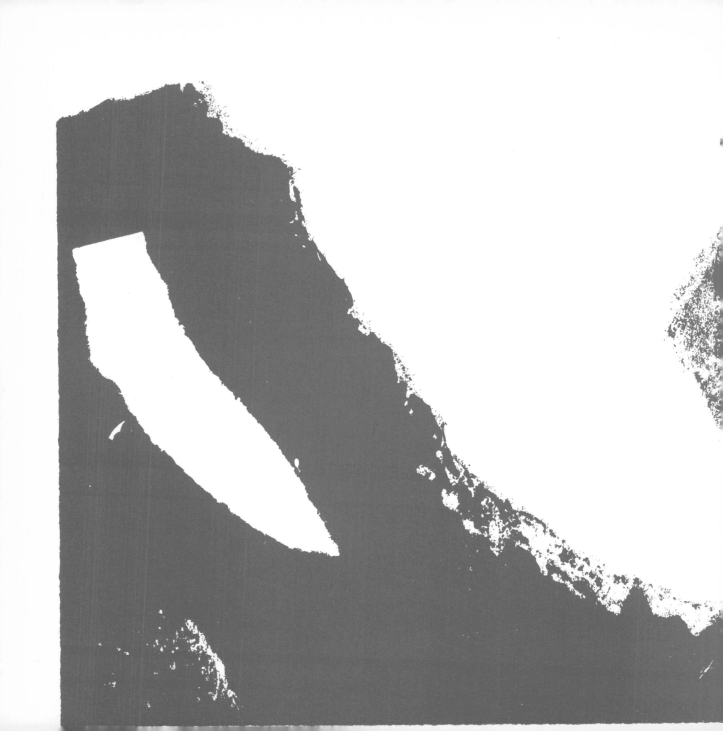

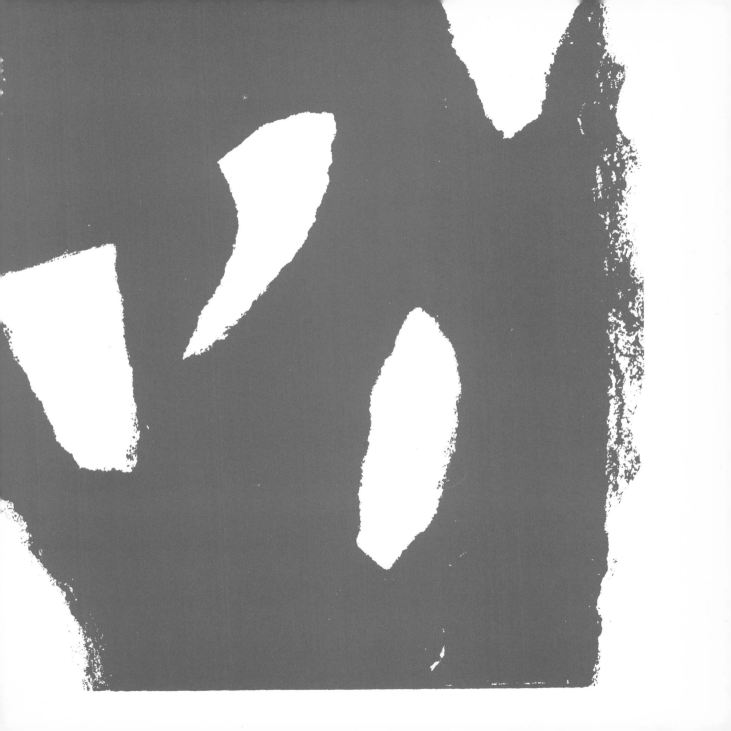

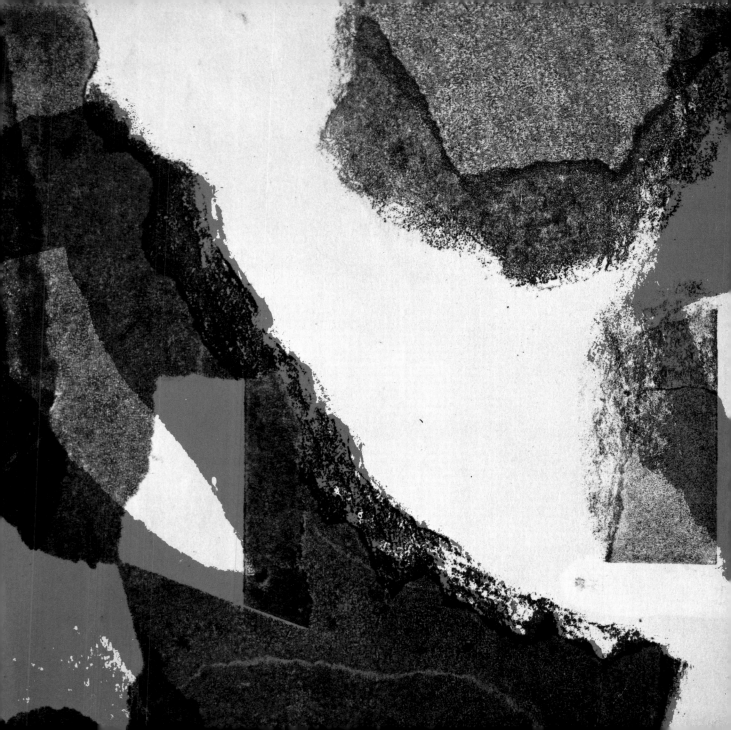

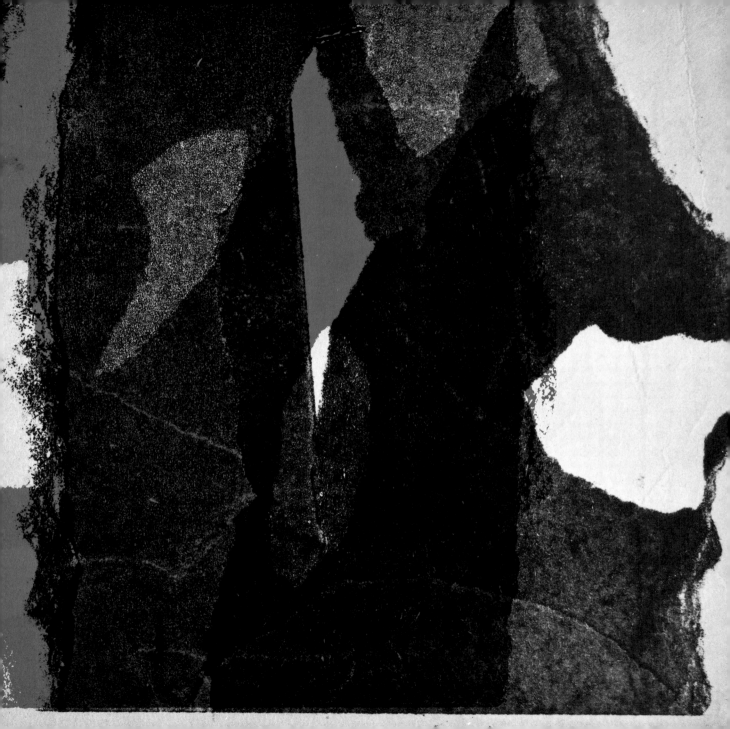

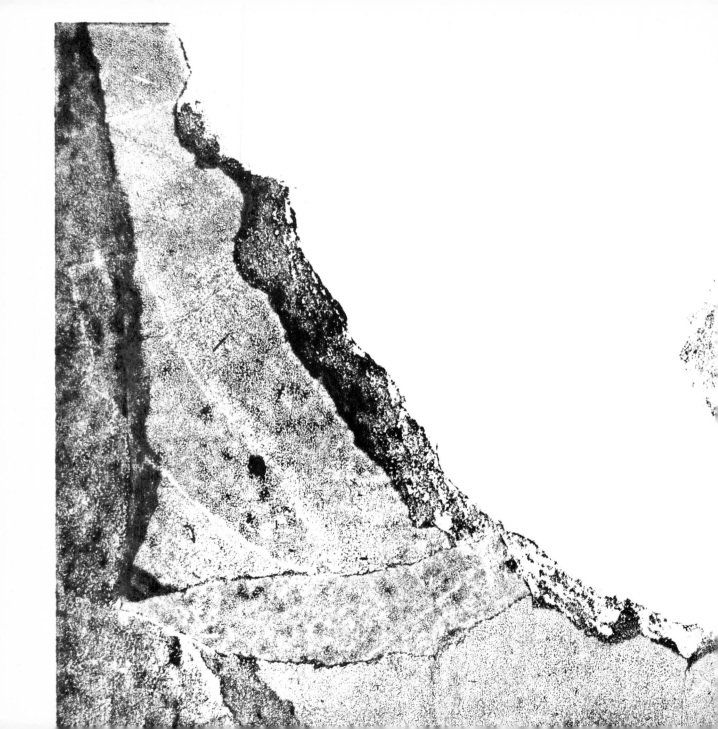

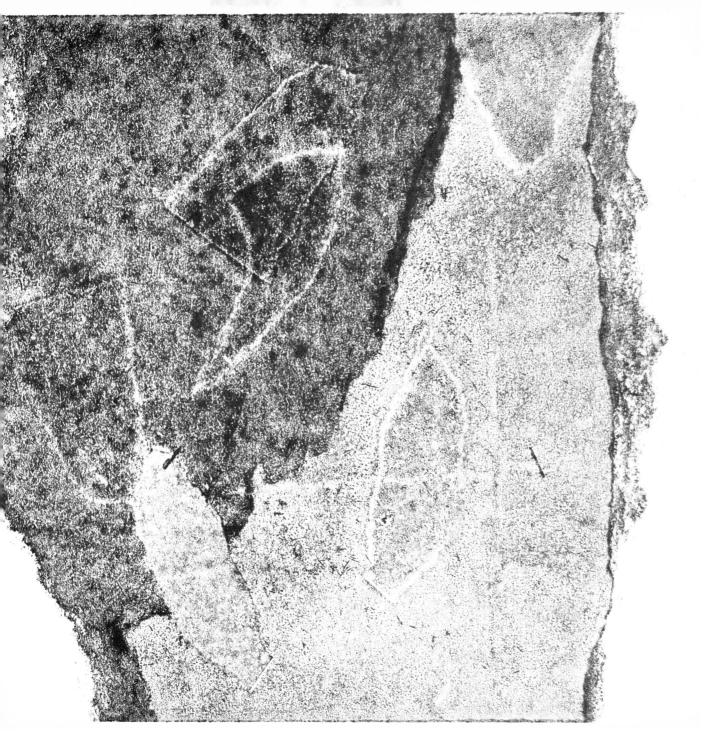

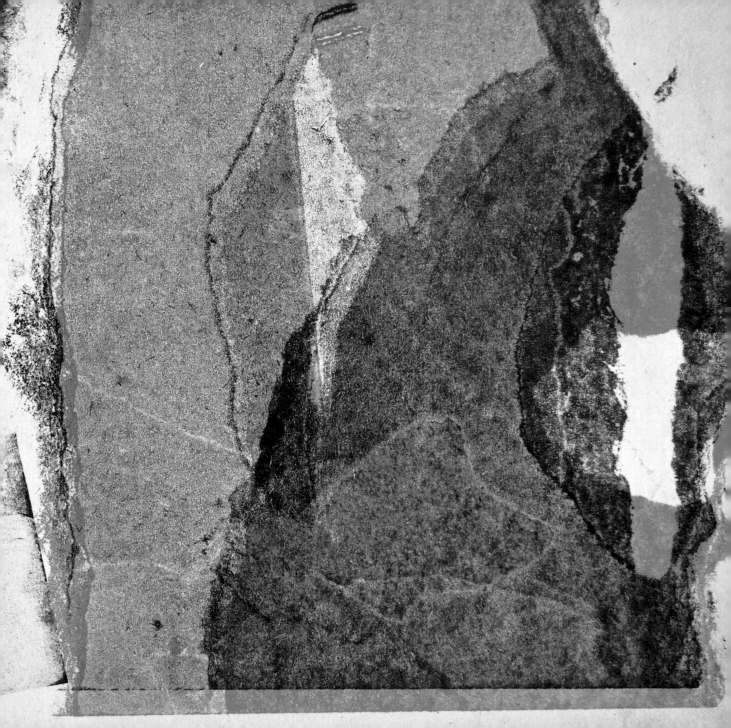

Registration of colour

One of the most vital factors making up a whole print image is the adjustment of colour to colour, overprinting, and the accurate placing of a second or third printing over, against, or in the middle of a previous one.

The process is a simple one, and once a few methods have been tested, it just becomes a part of the printing plan.

The most direct process is the placing of one block over another of identical area; in fact, three or four blocks may be treated in this way. First, place a plain sheet of paper on to the press bed and mark on it the exact outside measurement of the block which will have been placed on it after being inked. Pin the printing paper temporarily to this base at one (short) edge, and allow it to fall over the inked block. So long as the paper is always put in the same place, and the blocks on to the marks already made, all successive prints will be in register. If you do not want to damage the printing paper, for example if it has a hand made edge, make a fold in the base card or paper and tuck the printing paper neatly into it, lined up by a pencil mark at the edges.

New problems arise when blocks of differing sizes are to be registered. In most cases it will be easy to print these irregular pieces face downwards on the press bed, or on a flat board on the floor or a table. If the additional pieces

are small, fitting into the area of the main block or into a hole already made in the main block, they may be printed facing upwards or downwards. Little skill is needed beyond an accurate visual placing of the pieces.

Blocks must be held firmly with thumb and fingers and put down cleanly to avoid smudging or slurring in printing.

A few experiments will show that the order in which a colour is printed causes considerable variation in the nature and quality of that colour. For example, a pale yellow ink or pigment printed on to a clear white paper, will allow light to come through the ink, even if this is opaque, and a brilliant colour will result. If the same yellow is printed on a piece of lavender paper, or over a previously printed area of, say, blue ink, the first print will be ginger in colour, and the second print will produce a green zone over that part of the paper which has already received the blue ink.

Offset If a roller is rolled over an inked block and then over a piece of plain paper, a print will appear in reverse of the original impression, depending on the circumference of the roller. When the circumference of the roller has once been passed, the offset print will be repeated in a much paler tone, and this tint will diminish through any further rollings. Clean, delicate prints can be obtained in this way, and these can be overprinted by direct impression in any other following colour.

As they are low in ink content offset prints will dry very quickly; they are therefore useful in the printing of cut-out or make-up designs where there is a variety of colour and delicate tint. Type, wood letters, and cut-out letters mounted on card can be inked, and then the roller passed with pressure over the paper to be printed. A soft type of roller will get better results than one with a hard plastic surface.

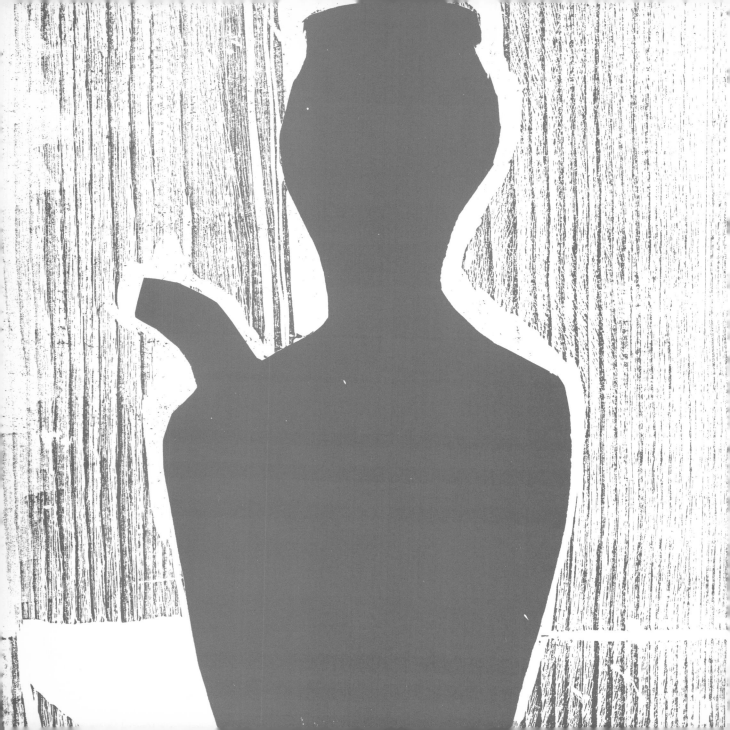

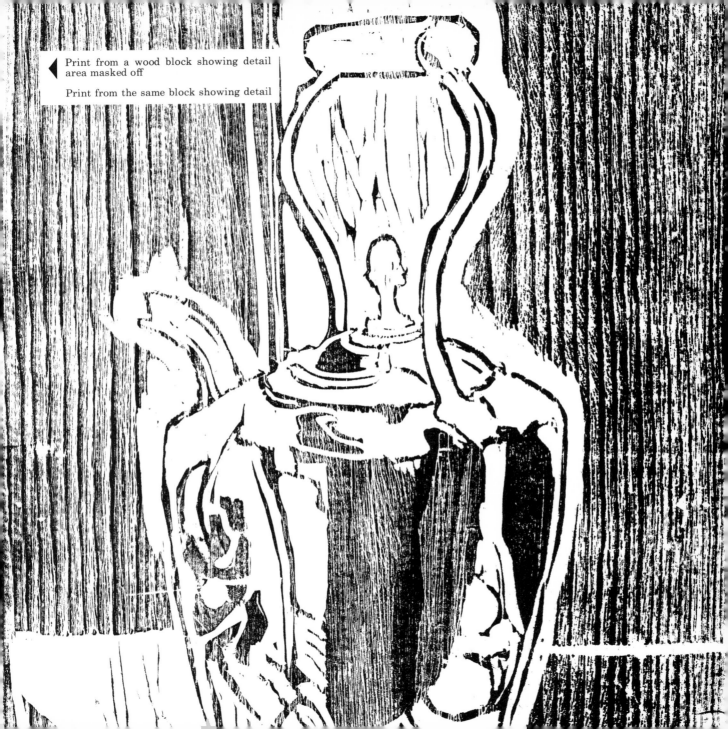

Print from a wood block showing detail area masked off

Print from the same block showing detail

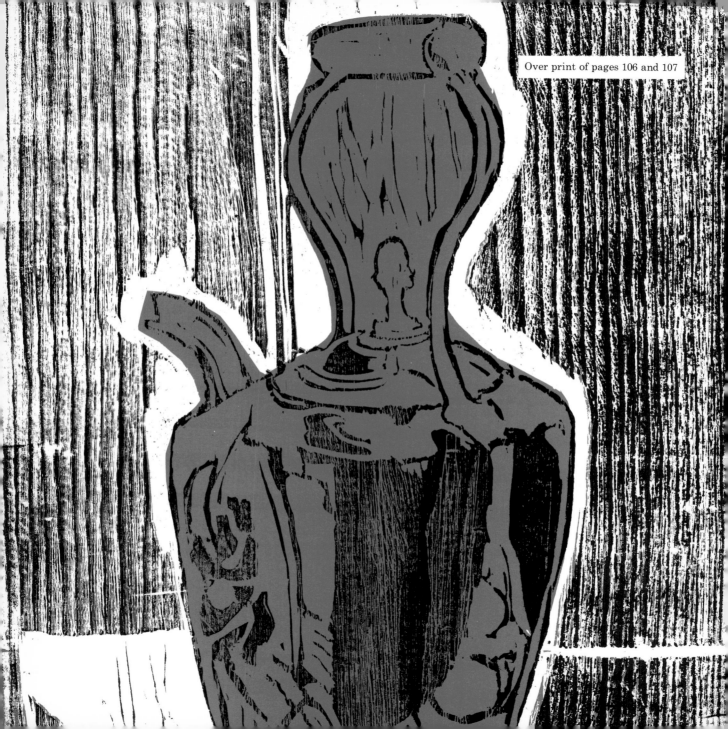
Over print of pages 106 and 107

Print using simple forms with small
areas masked off

Print using simple forms with colour

Print using simple forms on tinted ▶
paper

112

Prints in tones of black

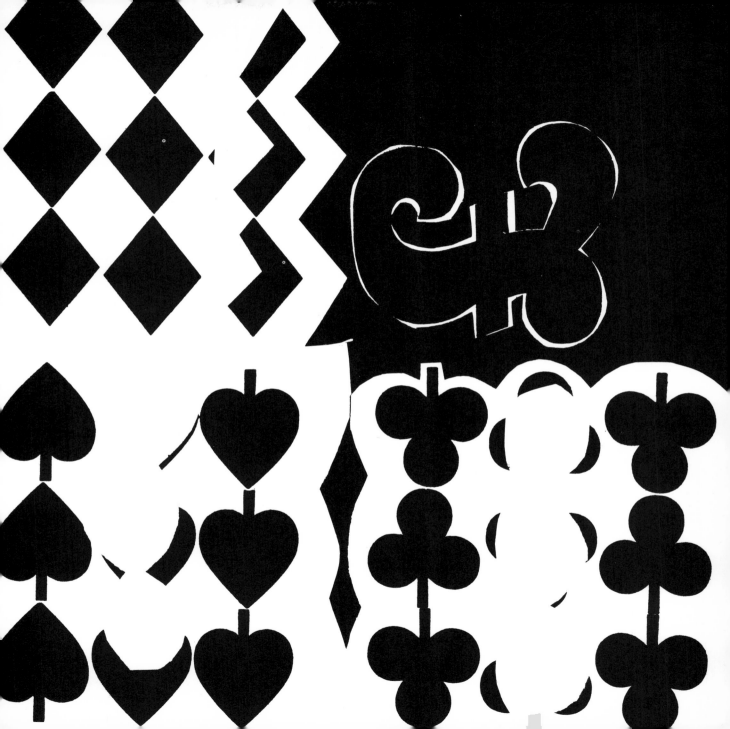

Letters and letter forms

It is comparatively easy to make prints from any large letter forms. A simple way is to cut out in a firm, clean edged card, a letter approximately 50 mm (2 in.) high, traced or drawn from a piece of printed type from a book or a magazine advertisement. The letter which has been cut can be used as it stands, and later the place from which it has been cut can be added or used elsewhere. In the case of the letters ADQBPDPRO the centres of the circles will fall out and there will not be any stencil form left; at the same time the space from which they have been cut can still be put to some use in the making of a composite image.

Sometimes trade printers are willing to sell old wooden or metal letters which they are not likely to use, and which may have been taking up storage space for many years. These letters will be type high (that is about 25 mm [1 in.]). For best results they should be locked into a printer's metal forme, if one is available, or simply tied together with thin, strong string.

Printing will be best from a press in this instance, but good proofs can be made either by burnishing, with the paper on top of the type, or by holding the tied type very firmly and putting it face downwards on to the paper to be printed. A top board may also be used with type placed over the paper and put under foot or weight pressure.

It is not easy to find printer's metal, and students will probably find it more convenient, and to some extent more rewarding, to trace, draw and cut out their own letter forms with a good pair of scissors or a sharp craft (mat) knife.

Letters can also be cut in lino. First, coat the lino with a very thin film of white or pale toned poster or gouache water-based paint. Then draw the letter on the lino in pencil, or trace it from type as previously suggested. Next, with a V shaped cutter, make a single line for the outline of the letter. Finally clean away the inner spaces with a gauge shaped cutter or knife. This is obviously a bigger job than cutting or mounting letters on card, but the speed in printing from lino will be an advantage if several copies are required.

A less skilful, but in some ways more honest, result may be obtained from the lino by cutting around the letters roughly, so that the freedom of cutting will be imparted to the printed result.

A further method is to cut the letter shape out of the lino, so that if printed in black ink on white paper, a white letter would appear on a black background. If it were printed on coloured paper in black ink, a coloured letter will appear on a black background. It is possible to make your own type by this method, in reverse or positive, in lino or card, but the letters must, of course, be cut into rectangles or squares like children's bricks, or they cannot be moved about.

Letter forms in upper or lower case, symbols, single design units and figures can be most useful to the print-maker. It should be noted, however, that in printing, especially in a press, bearer or protecting pieces the same height as the lino must be put round the cut areas to prevent embossing of the press packing.

Wooden letters and paper

117

THIS FACE
YOU GOT THIS
HERE PHIZZOG YOU
CARRY AROUND YOU
NEVER PICKED IT OUT
FOR YOURSELF AT ALL AT
ALL DID YOU ? THIS
HERE PHIZZOG SOME
BODY HANDED IT TO YOU
AM I RIGHT ? SOMEBODY
SAID HERE'S YOURS NOW
GO SEE WHAT
CAN DO WITH
YOU SOME
BODY SLIPPED IT TO YOU
AND IT WAS LIKE A PACK-
AGE MARKED NO GOODS
EXCHANGED AFTER
BEING TAKEN AWAY
THIS FACE YOU
GOT

118

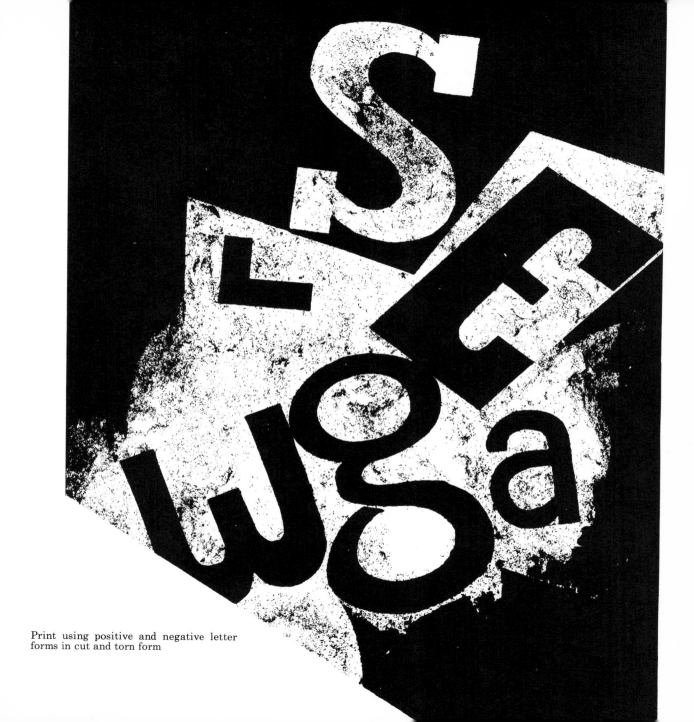

Print using positive and negative letter
forms in cut and torn form

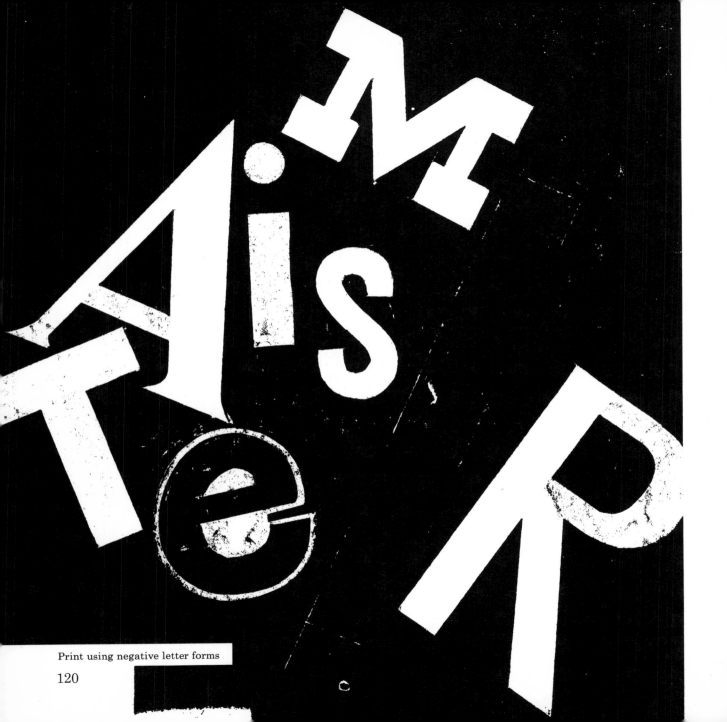

Print using negative letter forms

120

Print using wooden type

Printing on linen, canvas, silk, glass, polythene or waste products

For silk or linen, the fabric may be laid either on the bed of the press or printing board, with the inked block face downwards on top of it, or it may be gently laid in position over the inked surface. Certain man-made fibres and some silks will print more evenly if stretched over the edge of hardboard (fibreboard), light blockboard (chipboard) or *Perspex (Plexiglas)* and secured all round with paste to avoid folds or ridges on the surface. Polystyrene (Styrofoam), in its various stages of compression, is a good printing surface, and can be used in a press to good effect.

Canvas will need considerable pressure and a generous inking; probably a little paper over padding will be required, as the weaving of the fabric presents a surprisingly small area to receive ink.

Plate glass or good thick mirror glass can be printed safely by hand roller pressure or by offset from a roller image or from a print which has just been made. With gentle pressure and hard, clean packing, glass may be

Print from dress lace

used in a hand press. Two or three overlays of colour or additional workings may be made on glass or mirror pieces by this method. It is important that the glass, the bed of the press, and any packing used must be carefully cleaned to remove any grit particles.

Waste materials of many kinds can be used for printing by press or roller processes, in particular those used to protect goods from damage in transit such as cut card, with shapes and apertures, as used to pack glassware, electrical apparatus, Easter eggs, or chocolates; also plastic, lightweight containers for fruit and small wooden crates stamped with traders' names, trademarks and symbols. All these things can be cut, edited, and re-assembled for use in printing. Dressmakers' and tailors' wastebaskets will also provide a fund of useful materials.

Print from lace tablecloth

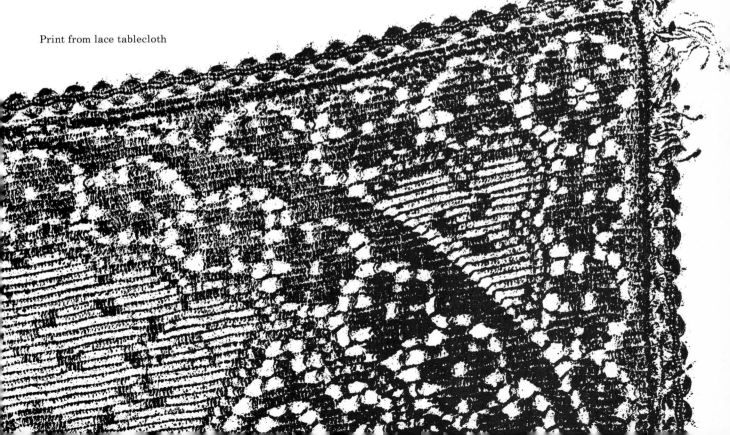

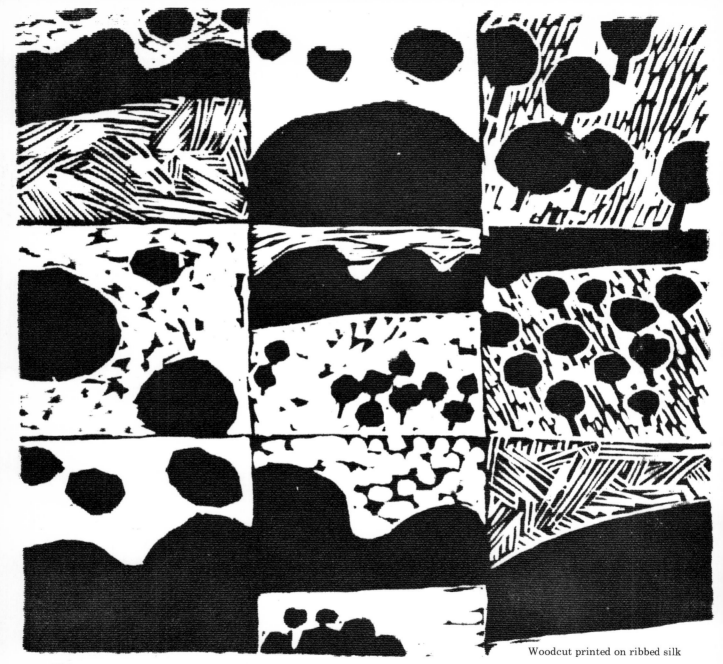

Woodcut printed on ribbed silk

Bibliography

Andrews, Laye, *Creative Rubbings*, Batsford, London: Watson-Guptill, New York

Biegeleisen, J. I., *Screen Printing*, Watson-Guptill, New York

Elam, Jane, *Introducing Linocuts*, Batsford, London: Watson-Guptill, New York

Erickson, Janet, and Adelaide Sproul, *Printmaking without a Press*, Van Nostrand Reinhold, New York

Gorbaty, Norman, *Print Making with a Spoon*, Van Nostrand Reinhold, New York

Green, Peter, *Introducing Surface Printing*, Batsford, London: Watson-Guptill, New York

Hartung, Rolf, *Creative Corrugated Paper Craft*, Batsford, London: Van Nostrand Reinhold, New York

Kinsey, Anthony, *Introducing Screen Printing*, Batsford, London: Watson-Guptill, New York

O'Connor, John, *The Technique of Wood Engraving*, Batsford, London: Watson-Guptill, New York

Rothenstein, Michael, *Linocuts and Woodcuts*, Studio Vista, London: Watson-Guptill, New York

Rothenstein, Michael, *Relief Printing*, Studio Vista, London: Watson-Guptill, New York

Röttger, Ernst, Dieter Klante and Friedrich Salzmann, *Surfaces in Creative Design*, Batsford, London, Van Nostrand Reinhold, New York

Woods, Gerald, *Introducing Woodcuts*, Batsford, London: Watson-Guptill, New York

Suppliers

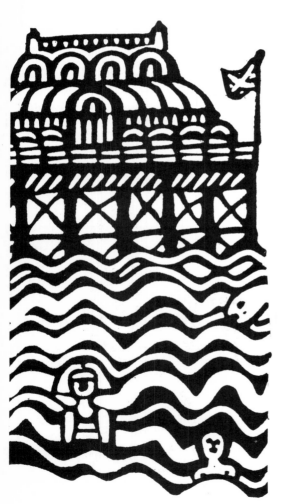

GREAT BRITAIN

Paper

Barcham Green Ltd, Hayle Mill, Tovil, Maidstone, Kent

Grosvenor Chater and Co Ltd, 68 Cannon Street, London EC4

T. N. Lawrence, Bleeding Heart Yard, Greville Street, London EC1 (also *Tools*)

Spicer Cowan Ltd, 19 New Bridge Street, London EC4

Strong Hanbury Co Ltd, Peterborough Road, Fulham, London SW7

Inks

A. Gilby and Son Ltd, Reliance Works, Devonshire Road, Colliers Wood, Surrey (also *Rollers*)

F. Horsell and Co Ltd, Howley Park Estate, Morley, Leeds

Mander-Kidd Limited, St John's Street, Wolverhampton

Shuck Maclean and Co Ltd, 5-7 Ireland Yard, London EC4

Usher Walker Ltd, Chancery House, Chancery Lane, WC2 (also *Rollers*)

Winstone, Parson and Fletcher, Winstone House, 150 Clerkenwell Road, London EC1

Presses

E. G. Gallon Ltd, Bankerend Mills, Bradford 3

Hunter Penrose Ltd, 109 Farringdon Road, London EC1 (also *Rollers*)

Kimbers Etching Suppliers Ltd, 16 Elm Avenue, Eastcote, Ruislip, Middlesex (also *Tools*)
W. C. Kimber Ltd, 24 Kings Bench Street, Blackfriars, London EC4
T. E. Knight and Co Ltd, 71 County Street, London SE1
G. and F. Milthorp Ltd, Vicarage Street, Wakefield

Rollers
Algraphy Ltd, Willowbrook Grove, London SE15
Ault and Wiborg Ltd, Standen Road, Southfields, London SW18 (also *Inks*)
Griffin's, 20 Britton Street, London EC1 (also *Tools*)
Louis Minton Ltd, 52 Corporation Street, Manchester 4

Tools
Alec Tiranti Ltd, 72 Charlotte Street, London W1
Wolf Power Drill and Tool Company, 69 Chancery Lane, London WC2

USA

Most of the equipment and supplies required can be obtained from any large art and craft supplier. The following general suppliers also issue mail order catalogs:

Arthur Brown & Bro, 2 West 46 Street, New York, NY 10036
A. I. Friedman, Inc, 25 West 45 Street, New York, NY 10036

Printing supplies
J. Johnson & Co, 51 Manhasset Avenue, Manhasset, NY 11030
Active Process Supply Co, 457 West Broadway, New York, NY 10012

Knives and cutting tools
Craftools Inc, 1 Industrial Road, Woodridge, N.J. 07075
Griffin Manufacturing Co, 1658 Ridge Road, East Webster, NY 14580

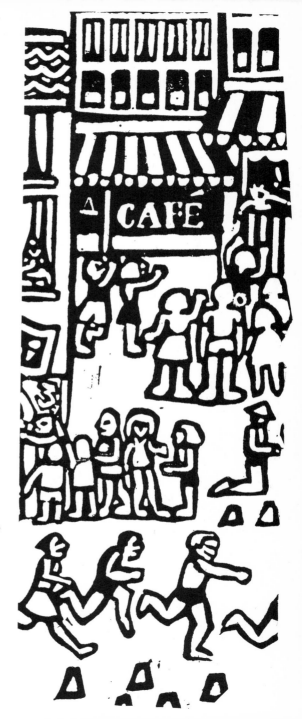

Rollers
Rapid Roller Company Ltd, 2556 S. Federal Street, Chicago, Ill 60600
Becker Sign Supply Co, 319-321 N. Paca Street, Baltimore, Md 21200

Inks
Colonial Printing Ink Co, 180 E. Union Avenue, E. Rutherford, NJ 07073
Standard Supply Co, 54 West 21 Street, New York, NY 10010

Self-stick products
Kleenstick Products Inc, 73 Murray Street, New York, NY 10007
Coating Products Inc, 275 Lincoln Blvd, Middlesex, NJ 08846

Papers
Wellman Paper Co, 308 West Broadway, New York, NY 10012
Hobart Paper Co, 11 West Washington Street, Chicago, Ill 60600

NE
850
O25
1973

O'Conner, John.

Introducing relief
printing

790993

DATE	BORROWER'S NAME	